Vibrant Acrylics

Hashim Akib

Search Press

First published in Great Britain 2012

Search Press Limited
Wellwood, North Farm Road,
Tunbridge Wells, Kent TN2 3DR

ISBN: 978-1-84448-697-7

The Publishers and author can accept
no responsibility for any consequences
arising from the information, advice or
instructions given in this publication.

Readers are permitted to reproduce any
of the items/patterns in this book for
their personal use, or for the purposes
of selling for charity, free of charge
and without the prior permission of
the Publishers. Any use of the items/
patterns for commercial purposes is not
permitted without the prior permission
of the Publishers.

Suppliers
For details of suppliers, please visit the
Search Press website:
www.searchpress.com.

Publisher's note
All the step-by-step photographs
in this book feature the author,
Hashim Akib, demonstrating acrylic
painting. No models have been used.

Printed in Malaysia

Acknowledgments

My thanks to Mark, Bjorn and Yogesh at Daler Rowney for their continuing support and for supplying the art materials for the book.

To everyone at Search Press, especially Edd, for making sense of my ramblings.

To students past and present for their interest, enthusiasm and wonderful artistic creations. My appreciation to the galleries that represent my work.

Thanks Dad, Natrah, Jamel, Mich and the boys, and to my beautiful partner Marie who fed and watered me throughout the writing and painting process.

Page 1
Early Morning Glow
Intense sunlight breaking through foliage is something I come back to again and again in my paintings. It is all-encompassing and creates wonderful variations of both tonal values and contrasting colour combinations.

Page 3
Yellow Parasol
This painting was completed in forty-five minutes, and although it is rough around the edges, there is a spark and flair unachievable with labour-intensive brushwork.

Opposite (top):
Columbia Road
Looking at crowds or individuals as collections of shapes and colours allows for freer brushwork and invites more interaction from the viewer to complete the picture.

Opposite (bottom):
Detail of Benny
The full step-by-step project from which this detail is taken can be found on pages 70–77.

Vibrant Acrylics

 # Dedication

To my mum and inspiration, Jenifer.

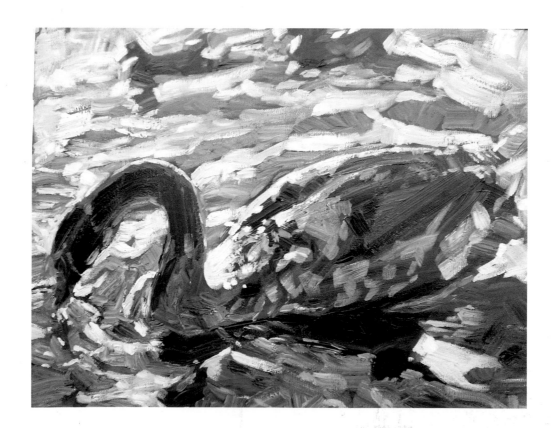

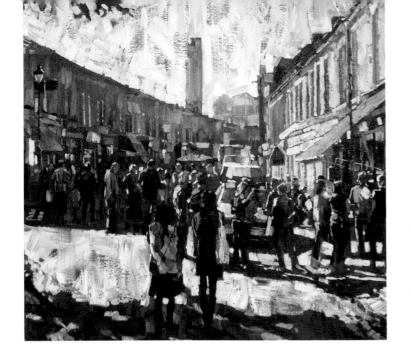

Contents

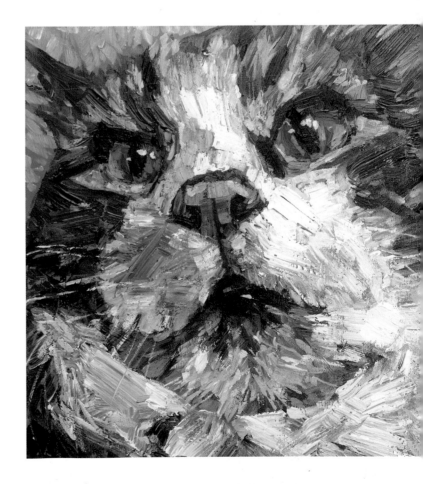

Introduction

The best tool for learning how to paint is paint. Anyone can theorise until they are blue in the face, but nothing is more important than the practical processes you go through. The more you practise, the more mistakes you will make and correct, and soon your confidence will grow. This new-found confidence will make you more assertive, which is the key to unlocking your full creative potential. Experience is a great thing.

Finding shortcuts is an illusion, and a specialised brush is only special if you know how to use it. In this book you will discover how to use luscious quantities of pure, undiluted paint in the purest acrylic style. Big brushes and dramatic and contrasting brushstrokes are utilised to quickly and effectively build up the picture, while refinement is reserved for the very last stages of your paintings to ensure that there is the least amount of fuss. With this method, you will begin to produce fresher, richer paintings.

This book covers a variety of themes including still life, animals, landscapes, portraits, crowds, architecture, and even abstract work, with plenty of insights from over twenty years of experience. If you can not wait to start, try the exercise 'paint a flower in fifty brushstrokes' (see pages 52–55) and you will see just what you can accomplish in a short space of time.

I hope you enjoy the journey as much as I have – and still do every time I pick up a brush.

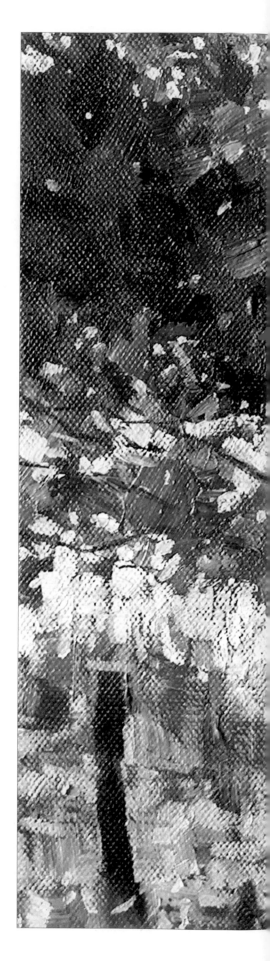

Sunrise

Sunlight streaming through trees is great to paint, especially in acrylics. The strong light source penetrates through rich darks and creates lovely glows of colour where light comes to rest. Here a purple base colour unifies the painting and contrasts the greens and yellows that follow. Rich reds and yellows, used prior to applying white, replicate the heat coming from the sunlight.

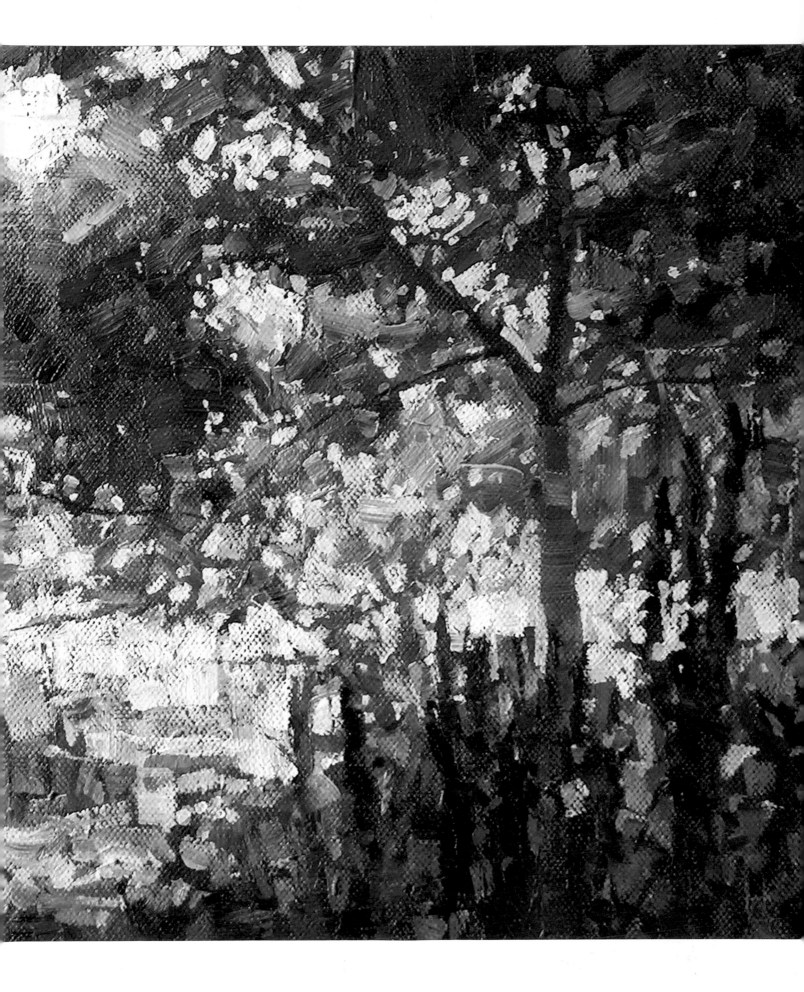

Acrylics

It has been said many times that acrylic paints are the most versatile medium around. They can be watered down like watercolour or used neat, straight from the tube, much like oils. However, acrylics should be recognised as a potent medium in their own right, with techniques specific to them.

Advantages and disadvantages of acrylics

Acrylics are relatively new in comparison with oil and watercolour paints. They were first introduced in the 1950s and 1960s, and were taken up by Pop Artists such as Peter Blake and Bridget Riley. Advances in the manufacturing processes since their inception mean that acrylics are now at the forefront of contemporary painting media.

When I started using acrylics twenty years ago, the range of pigments was quite large, and over the years manufacturers like Daler Rowney have introduced enhancers like texture gels of different variations, as well as unique paints such as fluorescent and metallic colours. This means that the range of effects and colours is huge.

The quick-drying nature of acrylics has the advantage that you can work a painting from start to finish in one sitting, and the producers of oil paints are following the lead of acrylics with fast-drying versions.

When you are just starting out you should try a whole range of techniques to find which ones suit you best. However it is not for the medium to adapt to the artist, but the artist to adapt to the medium.

You can create very effective watercolour effects with acrylics but they will not be as subtle or translucent as watercolour. Similarly, blending acrylics and overstretching the pigment like oils will leave unwanted streaks and a chalky appearance to the colour. Even combining acrylics with mediums and flow improvers that enhance the richness will not mimic the true essence of either watercolour or oil. With experience these shortcomings will become more apparent. However, when used to their full potential, acrylic paints produce unrivalled rich layering, expressive brush marks and luscious flows of pigment. The key to every medium is to be flexible and work with it rather than against it.

Coming to acrylics from other media

If you are an absolute beginner, then it is best to start with a drawing medium such as pencil, pen or coloured pencil. You will have a fine tip to work with and absolute control.

Oil and chalk pastels will give you more length of pigment and the opportunity to be more expressive. Pastels have superior blending qualities to acrylics, but can be unstable if unfixed.

When you are ready to graduate on to a painting medium, acrylics provide the most value. Acrylics are similar to oils, but being water-based are easier to work with and to clean. Undiluted acrylics are opaque and you can paint over layers or over mistakes. It is the most durable medium and being produced from plastic, colours remain as you painted them for longer.

Watercolour paints tend to be a preference of many for their portability and unrivalled translucent qualities. However, watercolour is the most difficult and unforgiving medium to master and will sap your confidence quicker than any other. Acrylics will not give you the subtlety of watercolour but they can be watered down to mimic the medium.

Opposite:
Water Glow

I am a big fan of the art movement Fauvism, typified by its strident colours and strong brushwork. Strong colour plays a vital part in my work. In this painting a potent red base colour provides a rich base for the complementary greens and blues. Much of the red still shows through at the end, and through optical colour mixing with the flecks of cobalt blue, the red ground creates a purple.

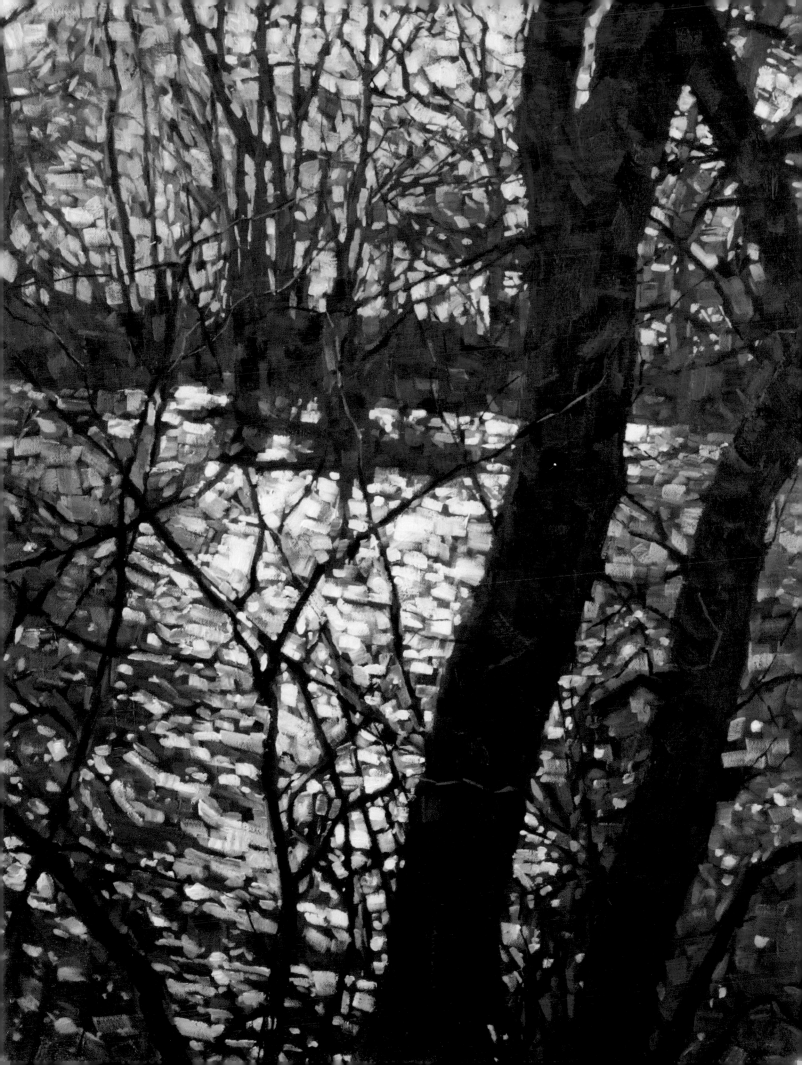

What makes a good painting?

There are a number of qualities that every successful painting should have, from technical considerations like the choice of colours and arrangement of the principal shapes, to more abstract elements such as your personal enjoyment of the painting process.

Enjoyment

One of the most important parts of painting is to enjoy the act of painting. If the artist enjoys the process of creating a work, it will show through in the result. Looking at paintings for me is like reading a book, with the marks, colours, tone and definition being a visual language. Elements such as colours, detail and subject matter in a painting can be useful in finding out what triggers our emotional responses, both as artists and audience. You may not even like what you see in a painting, but it can stay with you nevertheless.

On a technical level, it is easy to spot bad drawing, but it is harder to spot if it is intentional. There are some great artists who deliberately downplay their technical drawing skills, preferring strong colour, dramatic tone or simplicity to dominate. Enjoyment of the process is paramount.

Moving beyond your comfort zone

Most beginners want to paint realistically as this approach provides a comfort zone in art: making a painting look like a photograph means acceptability. Some artists will never move away from this method and will reach a high technical level.

However, replicating what we see so exactly means that any technical mistakes become more evident, which leads to more time obsessing about every facet of the reproduction process, which can be as frustrating as it is rewarding.

Beyond Realism

Discovering different forms of art sheds new light on painting. Discovering Impressionism, Expressionism or Fauvism for the first time can direct you away from technical exactitude and towards other equally valid expressions of art that you might find more rewarding. Evoking atmosphere and light with flecks of colours and brush marks relieves the tension of refined drawing, and gives a freer application of paint.

Looking at art will give you reference points as to what affects you most, but uppermost should be the enjoyment of the painting process. Feel good, feel passionate, and the journey will have as much to offer as the finished painting.

China Town

I have happy memories of the day spent in London's China Town where I photographed this scene. The resulting artwork hopefully reflects this mood and the enjoyment I had painting it. It is extremely valuable working from your own source photographs as you will have more emotional investment in the scene.

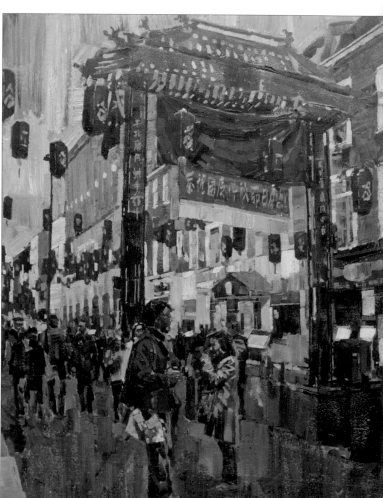

Composition

There are plenty of theories in art that aim to explain how to capture the most pleasing and harmonious compositions. While useful, some are based on very complex scientific calculations, so treat such rules of composition only as guidelines if you feel they might take all the fun away from your painting.

To start with, use your instincts; just as you would instinctively take a photograph of a scene you like. The viewfinder of a camera automatically gives you a cropped image, and you can duplicate this by making your own from a rectangular mount. Hold the mount up in front of your eyes and use it to frame potential scenes. By cropping out extraneous material, you can find some strong compositions.

Ultimately, the composition of a painting is successful if it goes unnoticed – few things spoil a painting than looking too planned and fussy; but when the composition is flawed, the painting can look awkward or unbalanced.

Tip

It is always useful to produce simple pencil thumbnails of the scene to see where the focal point works best.

The focal point

The most important facet of a composition is the focal point. This is the element or area of interest where the eye of the viewer is naturally led.

A long-standing approach for establishing a strong focal point in your compositions is to divide your paper or canvas into thirds, both vertically and horizontally. The focal point should land on one of the intersecting lines. Applying this rule will avoid placing the focal point slap-bang in the middle of the painting.

Using a geometric shape as a structure to base your painting on is also useful. A triangle works best with the centre of interest at the uppermost point.

Patterns and groups

When deciding how many elements to include in a composition, a good rule of thumb is to have an odd number. The brain naturally looks for patterns and will mentally pair up even numbers of flowers, people etc. Using odd numbers means there is always one thing left over which keeps the eye scanning the composition, sustaining the viewer's interest.

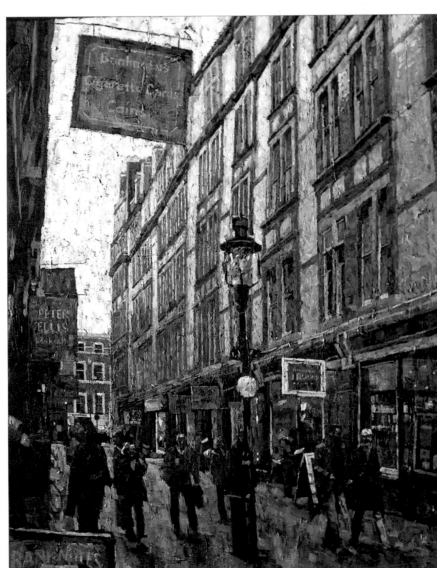

Hidden Treasures

All of the diagonals in this painting lead to the lower left, making the figure with the red jacket and the figure in the left foreground the focal points.

Freshness

Whether it is a busy street scene, a quiet park or an interesting portrait, there is a huge air of excitement, possibilities and enthusiasm when you first discover a scene to paint. This emotional impact can be difficult to sustain throughout the course of a painting. The deep concentration required to relate your interpretation of the tone, colour and definition of the scene to your canvas can be overwhelming.

Maintaining your level of freshness and optimism is imperative in reproducing what initially attracted you to the scene. Lazy and unnecessary brushstrokes are normally the sign of tiredness and despondency. You may start regretting choosing the scene, lose interest and become emotionally detached.

Maintain your enthusiasm

Taking regular breaks or working on several paintings at the same time is great for staying enthused. I have four or five paintings on the go at any one time and shift from one to another if I get bogged down. Working on varied subject matter – a landscape and a still life, for example – can challenge you and keep you on your toes. Looking at your paintings in a mirror can also be useful as the reverse image will show a fresh perspective and reveal any glaring mistakes.

By keeping that emotional spark lit, you will produce a more heartfelt impression of what first attracted you.

Charles Town Boats

It is rare that I paint pictures of boats bobbing on the water, but it made a change from my usual subject matter. Picking something new for you is a great way of exercising your skills and applying them to a fresh theme.

Preparation

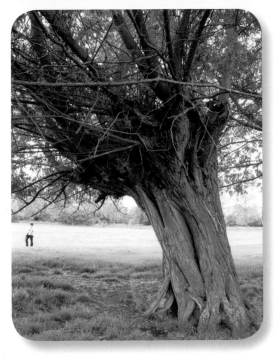

Where to work

Being organised and decluttering your workspace might seem more accountant than artist, but having access to all your materials when you need them keeps you focused on painting. Mundane tasks like refilling your palette with paint, finding an elusive brush or topping up your water pot are all unwanted distractions that can break your concentration.

Having a dedicated studio is a luxury that not everyone enjoys, but working in an area with plenty of natural light and a nearby table for your materials is nearly as good. Natural light is more conducive to painting then artificial light, as it gives a truer indication of colour mixes and helps to reduce or prevent eye strain. If you find it impossible to find a source of natural light, try using daylight bulbs in your light fittings, as these mimic natural light.

Source material

If you are working from photographs, spend a few minutes analysing the image before you begin. Think about the light sources and resulting shadows, and the colours that dominate, and identify the focal point. This is the area which will become the main focus of your painting.

Absorbing the information beforehand means you will not be coming to the painting cold and you will have some kind of strategy for tackling the scene. It might seem quite clinical to pre-plan, but over the course of the painting things will go wrong and being prepared means you will have a clearer idea of how to resolve any problems that crop up.

The source photograph for the painting below.

Less is more

Having suitcases or trolleys full of art materials every time you paint means more to clear up later. Once you are ready to paint, organise a maximum of five or six brushes and prepare your canvas or paper with a ground (see pages 28–29).

While the ground dries on your canvas, prepare your water pots, separate some sheets of kitchen roll, fetch some scrap paper to try colours out on and apply more paint to your palette than you feel you need. It is much better to have too much paint than to run out of it at a critical moment. With simple preparations complete, you need only build up plenty of enthusiasm before painting.

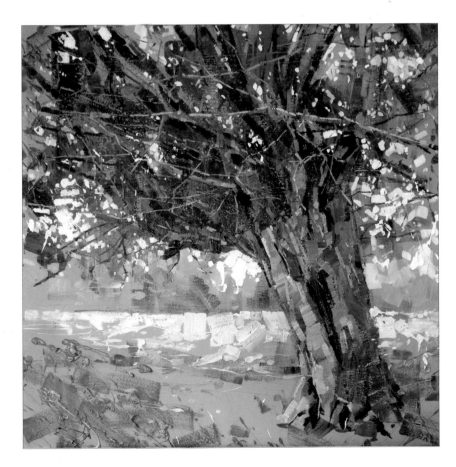

River Stour Tree

This sketchy painting resulted from the source photograph above. All of the basic elements of the tree are present, but the choices made throughout, in terms of colour and brushstrokes, make it far from a slavish reproduction.

Materials

If you have never used acrylics before, start with a small set of seven to nine colours with three to five brushes and an acrylic pad or watercolour paper. You will not need special enhancers or mediums to keep the paint moving: just use water to begin with.

An old plate will work well as a palette, and when you have finished painting for the day, you can place it in a plastic bag to keep the paint workable for next time.

Have a play, enjoy slopping paint around, utilise the limited resources and expand the range of materials once you have built up your confidence.

Tip

If you produce a painting you are not too happy with, you can always repaint the surface with white acrylic and start again.

Paint

There is a wide variety of acrylic paint available. Prices vary from the very economical students' grade to the more expensive artists' quality paints, which contain more pigment and less binder.

The paints I use are Daler Rowney System 3 Heavy Body, which are superior mid-range priced acrylics. This water-based paint range has a buttery consistency that retains brush marks and holds it in shape for gutsy textural and impasto effects. If you choose to use a different range, you should look for paints with these qualities.

System 3 Heavy Body has a range of thirty-four colours while the System 3 Original range – which dries to a smooth finish – has a range of sixty colours. Part of the reason I use this range is that there are colours unique to it, including the process pigments, yellow, magenta and cyan, which are suitable for screen printing.

You can experiment and try mixed media combining watercolour or pastel with acrylic.

Never mix oil and acrylic paint together, however you can start with acrylic and once dry finish the painting with oil.

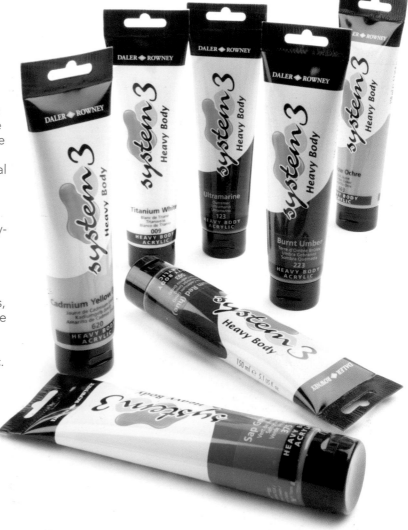

A selection of tubes of Heavy Body acrylic paint.

Brushes

Big is most certainly beautiful and most of the paintings I do are with my largest brushes. I work on relatively large canvases, but I would still recommend large brushes if you are working on small-scale paintings. You will produce them a lot more quickly, and that helps to keep your painting spontaneous and fresh.

The real advantage of large brushes is the amount of paint you can load. This not only cuts down on constantly refilling the brush, but as the quantities of paint glide over the canvas, colours streak in naturally and produce fresh colour mixing. Brushstrokes are more dramatic and the entire painting process becomes liberating.

One of the innovations of the Impressionist art movement was the introduction of flat head brushes which produced much more interesting brush marks. The awkwardness of portraying detail with a flat head brush is also an advantage in not obsessing. Round head and filbert brushes in acrylics can lead to over-blending and defining. For these reasons, I use Daler Rowney System 3 flat head brushes, the largest being a 50mm (2in) Sky Flow. I also use 37mm (1½in), 25mm (1in), 20mm (¾in) and 12mm (½in) brushes – any smaller and I find myself fiddling. The hairs are made from synthetic fibres, with the smaller sizes available as long or short flats, indicating the length of hair. Again, if you use another range, look for these qualities in your brushes.

It is extremely important to clean your brushes after use, as dried acrylic paint in the hairs can ruin your brushes. I rinse them thoroughly in water and remove the excess with kitchen paper.

My brushes. While the handles may get dirty, I clean the bristles and ferrules carefully after painting.

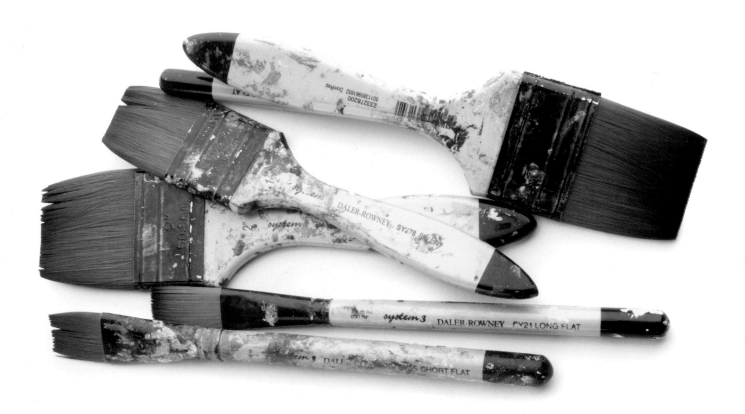

Surfaces

Canvas

I produce all my finished paintings on stretched cotton canvas as I find it the most practical surface to work on. Nowadays you can buy it from various outlets at very reasonable prices, with the most expensive being linen canvas. Canvases come in a variety of shapes and sizes, including chunky canvases which provide more depth to the edges.

Canvas generally comes stretched, primed and ready for painting. However, if you are purchasing rolls of raw canvas, it will need to be stretched over a wooden frame and stapled in place so it is firm but not overly tight. Paint a few coats of gesso over it to prime or seal the surface. This will also tighten the canvas over the frame.

Unlike paper, there is no need to frame canvas, and I generally just paint the edges with a ground colour.

The wedges that come with canvases are there to keep the canvas taut if sagging occurs. Gently tap them into the inside corner gaps till they are firmly fixed.

Other surfaces

Among the surfaces you can apply acrylic to are fabric, wood, concrete, paper, cardboard, glass, plastic or metal. Most of these surfaces need to be prepared or primed beforehand so the acrylic can be applied smoothly and retain vibrancy over time. Unprepared surfaces may result in the paint peeling off.

When painting on watercolour paper in a thicker acrylic style it is a good idea to apply a coat of white acrylic over the surface. This way the paint will glide across the surface and not sink into the grain. It is also a good idea to tape the edges flat to a board to avoid warping while painting.

When working on other surfaces you may need to go to further lengths to prepare for painting. Here are a couple of examples of priming other surfaces.

Before painting on wood you will need to sandpaper the surface until smooth and apply two or three coats of gesso, leaving each layer to dry before applying a new coat. Sandpaper each coat when dry to maintain a smooth and even surface for painting.

Painting on plastic requires lightly sandpapering until the surface feels rough or provides a 'tooth' for the paint to grip. Varnish the finished painting when completed to protect the surface from scraping.

Tip

The general rule for priming: waxed or varnished surfaces should be prepared and primed before painting.

Certain surfaces require specialist mediums to create a painting surface.

Other materials

Easel

An easel allows you to produce more fluid brushstrokes, as your arm will not be resting on the edge of a table, which can create lazy strokes. It will also help with your posture as you will be working upright.

Table easels are useful, but I think a freestanding easel is better as it allows you to step back and get an overall impression of your painting.

Hairdryer

This is not essential, but handy if you want to dive straight in without waiting for base colours or very thick paint to dry naturally.

Water pot

It is a good idea to use a large pot if you are using large brushes. The large quantities of paint require more cleaning and you will need at least two just for the cleaning and one for rinsing. I use two or three medium-sized collapsible water pots, and sometimes a bucket.

Kitchen paper

Assume before you start painting that you will make a mess, and have plenty of kitchen paper around to mop up after yourself.

Kitchen paper is also useful for drying brushes after cleaning or to take away excess water.

Source material

Try painting from your own photographs. You will have a more intimate connection with the subject.

The importance of drawing

Drawing is the backbone of painting and mastery is achieved only with training and developing the eye through observation. It is important to distinguish between drawing, which is mostly technical, and painting, which is mostly emotional. Once you have developed the technical side of drawing, you will use that refined skill to look in depth at colour and brushstrokes, and you may start to re-evaluate the importance of representational drawing and even turn to abstracts.

Observation

Beginners should do lots of drawing in order to train the perception muscle. Sketch or doodle whenever possible as this is a guaranteed way of improving. As you progress, you will need to do less preparatory drawing as you begin to rely more on your immediate visual observations, but it is an enjoyable skill to practise so even very experienced artists will benefit from continuing to draw.

Drawing from life

What your brain can conceive is far more sophisticated than a camera. Drawing from photographs will only give you a fraction of what you might achieve through drawing from life. Observational drawing, whether from a still life, life drawing class or sketching outdoors, will provide a closer attachment to the subject, allowing you to observe elements from multiple angles and note subtleties in tone and colour.

Nowadays I do very little drawing but spend a considerable amount of time looking at the scene prior to painting. I use the skills developed through drawing to evaluate every aspect and extract what makes the painting work for me.

Self-portrait with Sock

This is how I used to paint, with a more meticulous and considered approach. This self-portrait was painted from life and photographs over several weeks. My work now is much more decisive and free, but the experience I picked up from observational drawing and painting are invaluable to my current work.

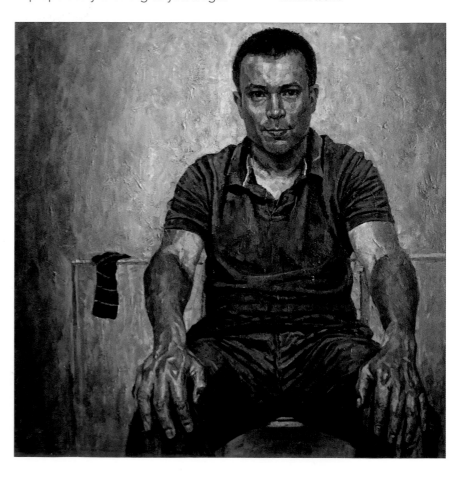

Simplify and loosen up

Intense drawing drains your concentration as well as your enthusiasm. Having an exact technical drawing in front of you when you begin to paint is reassuring, but will ultimately restrict your enjoyment and expressive ability. Imagine doing a completely refined drawing before even starting your painting – you would be thoroughly exhausted. It is very easy to create a habit of excessive drawing and extremely difficult to break. Remember that the technical skill of drawing realistically is a stepping stone or apprenticeship to discovering much more personalised interpretations in art.

On a practical level, try sketching in pen and ink rather than pencil, or avoid using erasers to correct mistakes. Both methods encourage you to adapt, improvise and appreciate a less precise form of drawing. Such an approach can be intimidating, but the risk of making a mess is outweighed by the great benefits such an approach will have on your drawing. The ability to learn and improve is only stimulated by challenge.

Graduate from pens and pencils on to charcoal or pastel, where you can utilise the entire stick and produce much more varied marks. When you are ready to move on, start sketching with paintbrushes, using both large and small brushes. Do some quick sketching exercises which will make you prioritise the information in front of you.

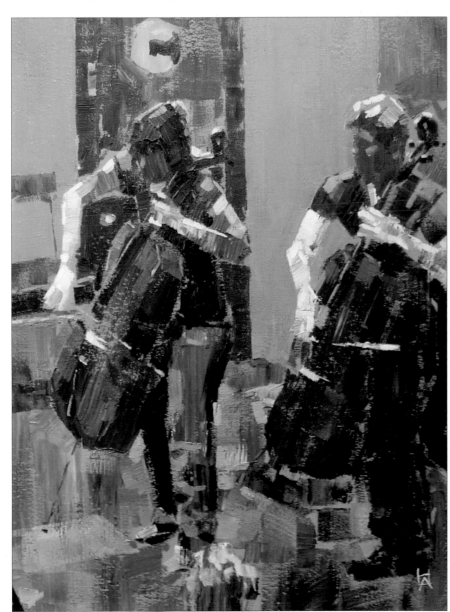

Covent Garden Musicians

This painting is based on some quick sketches of a couple of musicians in Covent Garden. The lack of information in the sketches led to simple brush marks to capture the essence of the figures.

Fundamental shapes

Preparing to paint complex images such as portraits, architecture or a crowd scene can be extremely daunting. When you initially choose an image, it is your logical side that provides the overall image, but it is your creative perception that must edit and manage the component elements. Even deciding certain subjects are not to our liking is unnecessary baggage. Everything has the potential of being an interesting topic to paint if you examine the fundamentals. These fundamentals include tone (light and dark), colour (the hues you use and their relationship with each other) and an interesting variety of line and shape.

Basic geometry

When tackling difficult scenes, the secret is to break the elements down into basic geometric shapes like triangles, squares, rectangles or circles. Houses can be squares, with smaller squares for windows and a triangle for a roof; a tree can be a circle with a small, upright rectangular base.

Start constructing simple scenes, such as a still life of apples or oranges, using circles. Once you have grasped the principles, graduate to more complicated themes. Drawing a portrait is one of the more complex types of drawing, but it can still be broken down into shapes: imagine the figure as a robot with a slightly elongated square head, small rectangular boxes for the eyes, mouth and ears, and a triangle for a nose.

Once you have the general proportions you can then add the adjustments of curving the head and jaw line, detailing the eyes, ears and mouth and you will be suitably impressed with the results.

Initial structure

You should avoid taking individual elements to a finished level before moving on, as this can lead to unforeseen problems. Consider the following scenario: the ear of a model is accurately and exactly depicted, so the artist moves on. The eye is then replicated beautifully, but unfortunately a slight overestimation of the scale means there is no space for the nose on the page.

Ultimately, no amount of detail or slick brushwork can ever cover up a badly conceived structure, so ensure the basic shapes are correct before moving on to develop them.

Even at this very early stage of my painting Tropical Taste, *the basic geometry of the shapes is already in place. Everything is worked on consistently without being drawn into detail. The finished painting can be seen on page 88.*

Outlines

Drawing an outline before painting is great for your confidence as you will have a guide to follow and appropriate areas to fill in with colour. Beginners need to develop drawing, so utilise outlines in your paintings as much as you can. As your confidence builds, you should naturally diminish the use of such detailed drawing before painting and use the absolute minimum.

To avoid an overly fussy outline, try using a large brush and paint to produce the outline, as in the examples below. Pencils have too pale a line and will diminish almost completely as you apply rich layers of acrylic. Use a large flat head brush with a midtone shade and apply loosely drawn strokes. Any mistakes or miscalculations can be rectified as you progress and become more accustomed to the scene you are painting. With experience you will be able to produce a rough sketch quickly, which will liberate you to explore more adventurous brushstrokes; leaving refined drawing till the latter stages of the painting.

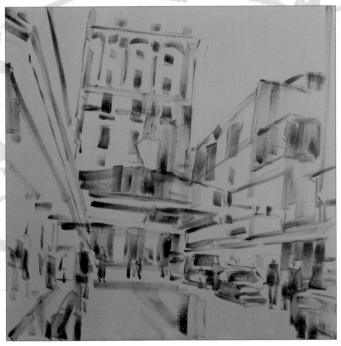

The outline for The Savoy. *The finished painting can be seen on page 46.*

Tip

Sketching every blade of grass or leaf on a tree is laborious and can sap your concentration and drain your enthusiasm for the subject. An extremely detailed outline can restrict your painterly marks as you will feel nervous about spoiling your line work, so keep the lines to a minimum.

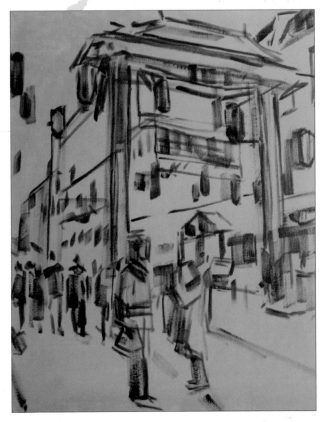

The outline for China Town. *The finished painting can be seen on page 10.*

Shading and tone

I love watching black and white films from the 1940s and 1950s because they are visually dramatic and full of atmosphere, which just goes to show how striking imagery can be created using only tonal ranges. We tend to think of the world in terms of hue and colour, but in painting tone should be the first consideration as it helps to create the dimensionality of the image. The essential ingredient is the light source or sources as this will dictate the line of shadows and reflected light.

Try painting using a single dark colour such as deep violet, and add varying quantities of white to investigate the pigment's tonal range. Start with pure deep violet for the darkest tone and then add increasing quantities of white for midtones and then the tints. The purest whites should be underplayed and applied at the very end to draw the eye to the focal point. Without having to worry about colour, you are free to experiment with a variety of brush marks. Regular vertical or horizontal strokes are great for smooth blends and irregular diagonal strokes are well suited for texture.

To judge how well your colour paintings work tonally, try photographing them in monochrome to see how dramatic the contrasts are. Another solution would be to squint your eyes to reduce the level of detail and emphasise light and dark. If the scene looks grey and flat, then the tonal ranges may not be working too well.

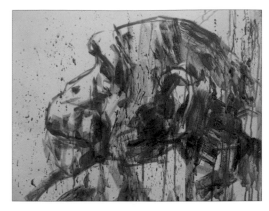

For this study I only used titanium white and deep violet. These provided a wide range of tonal values. With only tonal ranges to worry about, I had a good opportunity to experiment with marks, splattering and running paint down the surface. The purest highlights are applied to the ear and shoulder as these play against the deepest darks for maximum impact.

Study of Chimpanzee

I love the bone structure of this chimpanzee, especially from the profile. Maintaining the attractive sketchy feel of the study (above) provides a certain wildness to the painting.

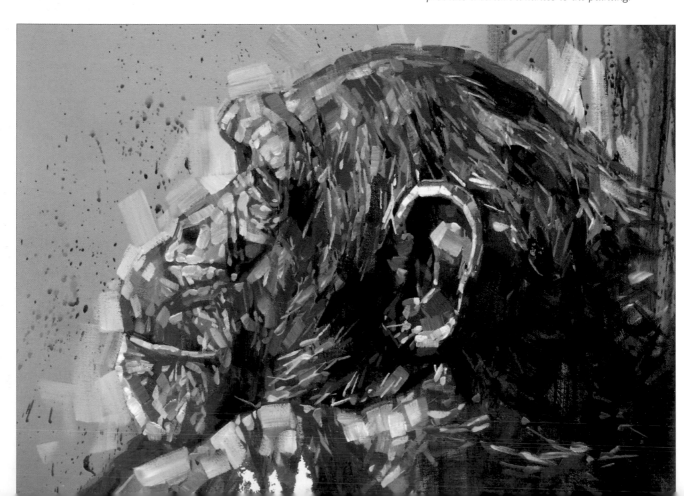

Softening edges

It can be quite tricky to blend acrylics to create soft edges and graduation of tone or colour. Their rapid drying time means your initial applications of paint can begin to dry as new ones are applied, which can create unwanted streaks or uneven blends. This can be particularly problematic for gradated skies or misty morning scenes.

Overworking the paint to smooth out the blending can result in a dull appearance. You can buy mediums or acrylic retarder to prolong the drying times but even these may take the luminosity of pigment away. The alternative is to load the brush with generous amounts of paint, then apply it to the canvas with variable amounts of pressure to create hard and soft edges.

Brushstroke length

Utilise your entire arm to draw out larger brushstrokes. Use the length from your elbow for mid-length strokes, and your wrist for short and defining strokes. If your preference is for detail, then maximising the length of your arm will prove very alien. Keep practising and you will soon find it second nature.

There is a particular energy to applications of paint that are not reworked or manipulated. Watercolourists see this effect with wet-on-wet applications in skies as the pigments blend and soften together. Keeping a similar freshness should be one of your overriding goals in acrylic painting: it is more important than precise detail.

When I start a painting, I use large, full-length brushstrokes all over the canvas to establish soft and connecting edges. Trees and fields in landscapes, or architecture and people in street scenes, are applied in quick succession to unify the elements. These may be just random blobs or dabs of paint to establish a shape. Once I feel I have exhausted the full length strokes I start looking to pull out definition with mid-length strokes. Finally, I look for full control and pressure with very short, controlled strokes for absolute detail and minimal hard lines.

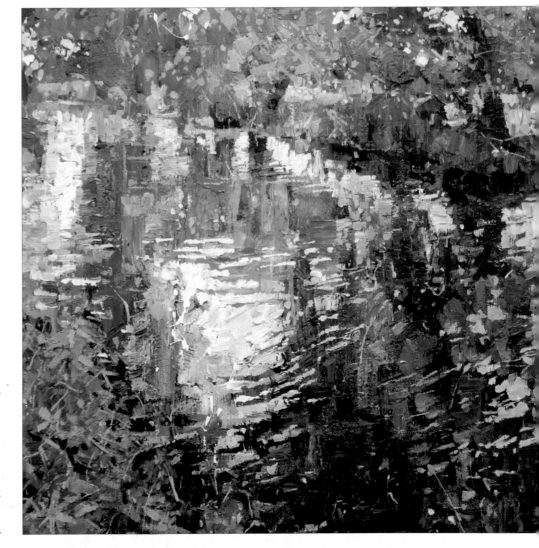

River Stour

For this painting I tried to connect the various elements as much as possible. I avoided too many defined edges, which makes for a more fluid visual journey as you scan the scene. Colours are kept cool and to a minimum to maintain the tranquil feel of the setting. I finished off with some heavy spattering in the main highlights.

Starting off

Before you begin, it is helpful to have a little knowledge of colour theory, how to use your paint and how to create striking paintings. Opening the door to colour will make you aware of the richness of colour all around you and provide invaluable insights. The following pages include advice and warming-up exercises, which aim to get you painting successfully and enjoyably as quickly as possible.

My palette

Generally, when people take up painting, their starter set contains less dominant and more versatile colours. These might include ultramarine blue, sap green and perhaps a couple of earthy shades like burnt umber and yellow ochre.

My palette tends to veer towards very dominant pigments, the richer the better. There are more risks involved in mixing such potent colours, but the rewards are greater. Dominant hues help you explore the boundaries of colour harmonies and colour conflict.

Burnt sienna This colour's transparency makes it ideal for mixing and creating subtle neutrals.

Cadmium orange This is the least used colour on my palette, so I reserve only half a well for it. Nevertheless, it provides a good contrast to the blues.

Cadmium red A standard red for mixing with green to create interesting browns, I also use it straight to draw the eye to particular areas.

Yellow ochre I prefer this to raw sienna because the ochre is more opaque. Use it sparingly as a lot can create flat areas of colour.

Cadmium yellow This is a great yellow for enriching certain colours and it is warmer than lemon yellow.

Lemon yellow This is essential for mixing in with white to spark highlights to life.

Cadmium yellow Because yellow becomes dirty so easily when loading your brush, a spare well is useful for ensuring you have clean paint when you need it.

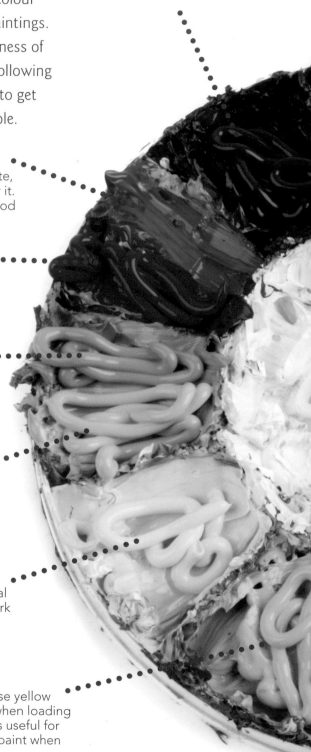

Sap green An earthy and versatile colour which contrasts the more dominant phthalo green. Useful in mixing to create softer, more muted shades.

Coeruleum blue This is the most used colour on my palette, ideal against the other cool darks in creating lighter shades. Great as a base colour when mixed with other colours.

Cobalt blue The other blues in my palette contain a greater amount of green so the red tinge in cobalt works more harmoniously when streaked in with warm colours.

Process cyan Unique to the System 3 paint range, process cyan is a rich, dominant, dark blue but when it is mixed with titanium white, it produces a glorious light tint.

Deep violet I use this in place of black or Payne's gray. When mixed with other dark-toned colours, deep violet gives velvety shadow colours.

Titanium white Titanium is more opaque than other white paints and that is crucial for highlights.

Phthalo green A potent green that will dominate other colours. Mixed with coeruleum blue and titanium white, it produces a lovely turquoise.

Process magenta This replaced crimson on my palette and is unique to System 3. Process magenta invigorates other colours when streaked in. It is also my favourite base colour when softened with white.

Loading your brush

The most vibrant paint is that which is freshly applied. Over the course of a painting more paint is applied, covering, layering, mixing and blending; which can dull the freshness of the pure paint.

To ensure vibrancy in your colours, avoid mixing them on the palette. Instead, load your brush with several pure colours by dipping it into successive wells of your palette to build up a thick, buttery load of intermingled colour. Because heavy body acrylics will not run into one another on your brush, this creates a brush with layers of pure, clean colours. When you draw the brush over the canvas, the outside of the load will adhere to the tooth of the surface, leaving the paint behind. This will blend some of the paint together as the layers on the brush interact, but it will also leave small touches of pure colour that interact with each other and the blended mix.

Allowing paint to mix directly on the canvas is just one way of keeping your colours rich. Try optical colour mixing by placing small dabs of unmixed colour next to each other on the canvas. The interaction between the colours creates interest and movement.

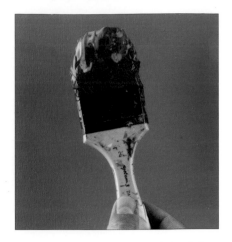

This brush has been successively loaded with cadmium red, cadmium yellow and cadmium orange. Note how flashes of the pure colours are still visible.

Grounds

Stark white paper or canvas can be really intimidating. The reluctance to spoil a perfectly even surface is the first hurdle to overcome before proper painting.

Take a large splash of colour and slosh it on with complete disregard for the white surface staring back at you. Applying this base colour, known as the ground, is a great way of asserting your authority and warming up your painting arm.

Beginning your painting with a ground colour in place speeds up the painting process as you will already have a midtone. The ground will also unify the painting if flecks are allowed to flicker through at the end.

In using grounds, try not to be too predictable. Experiment with a wide array of complementary,

harmonious, bright and muted base colours. The examples on the following pages show how different base colours can affect the overall look and feel of a painting; but the principle is simple: anything is better than a plain white background.

Allowing touches of a brightly coloured ground to show through on the finished painting can enhance the overall richness of the picture, particularly if the ground colour is complementary to the surface colours. Try a warm red for a seascape or yellowish-green for a portrait, for example, and you will create some stunning results. Swatches, like the examples shown below and on the opposite page, can give you ideas about the choice of ground to use for your painting.

Cadmium orange, process cyan and titanium white.

Lemon yellow, process magenta and titanium white.

Lemon yellow and titanium white.

Burnt sienna, cadmium orange and titanium white.

Deep violet, phthalo green and titanium white.

Cobalt blue, sap green and titanium white.

Cadmium red, process magenta and titanium white.

Process cyan and titanium white.

Cadmium yellow, deep violet and titanium white.

Lemon yellow, sap green and titanium white.

Cadmium red, phthalo green and titanium white.

Cadmium orange, burnt sienna and titanium white.

Cobalt blue, burnt sienna and titanium white.

Sap green, cadmium yellow and titanium white.

Sap green, burnt sienna and titanium white.

Cadmium orange, cadmium yellow and titanium white.

Process magenta and titanium white.

Cobalt blue, deep violet and titanium white.

Burnt sienna, deep violet and titanium white.

Phthalo green, cobalt blue and titanium white.

Phthalo green, cadmium yellow and titanium white.

Cobalt blue, burnt sienna and titanium white.

Cadmium yellow and titanium white.

Cadmium red and titanium white.

Complementary coloured grounds

Complementary colours are colours that are opposite each other on the colour wheel. Examples are yellow and violet, blue and orange, and red and green. Using these combinations can be tricky in large applications, but they work extremely well when one colour dominates the other or is used in small doses. When placed side by side, complementary colours appear brighter than in isolation.

White is an important component in a coloured ground. It will even out transparent pigments which may otherwise streak, and also soften darker-toned colours which are more difficult to penetrate with light colours.

Traditional base colours include yellow ochre or burnt sienna, and these are highly recommended to beginners for their versatility. If you want to use something more adventurous or dominant, such as bright red, try adding white to the pigment to make a soft pink.

In the painting opposite I used a ground made up of phthalo green and cadmium yellow, with titanium white added to soften the hue. The green plays off the figure in red in the midground and lifts the reddish browns in the buildings and bike; an effect that is more obvious in the part-worked version (right). The vibrancy in the colours here draws the eye to these focal points. Other complementary pairs are used in the following layers of paint to draw the eye to secondary focal points, such as the soft tints of purple and yellow on the father's trousers and jacket.

As the painting is built up, more of the ground is covered, but small fragments are left behind to provide a link between all the different parts of the painting. It is important to appreciate if the scene was painted on white, rather then green canvas, small pockets of the canvas or paper would appear, detracting from the actual highlights. Working directly on white canvas will also stimulate colour and produce artificially vibrant colour everywhere.

Strong grounds can appear overly-dominant in the early stages of painting, but as the finished version shows, even a dominant hue will blends and interact with the layers above to create a more balanced painting.

Father and Son

I like the story this scene tells: this painting shows that you can create a whole narrative without words.

It would have been obvious to play down colour and go for a more earthy palette to set the tone, but colours are uplifting and I wanted a more positive spin to the finished picture.

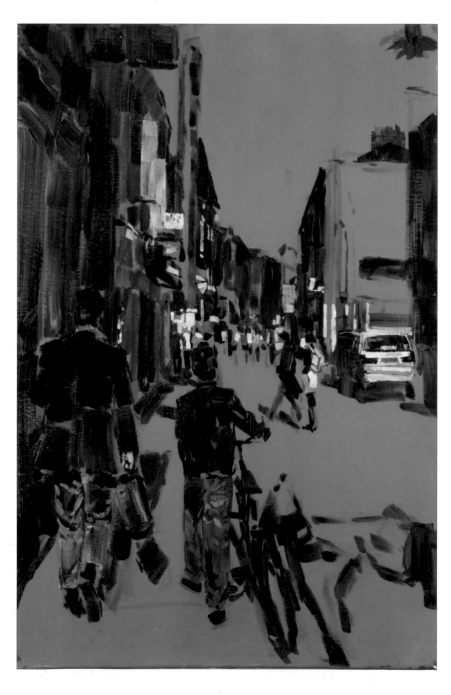

The green-yellow base colour is clearly visible at this early stage of the painting. Look for the same colour in the finished painting opposite. Tiny flashes appear here and there and help to bind a complex scene into a cohesive whole.

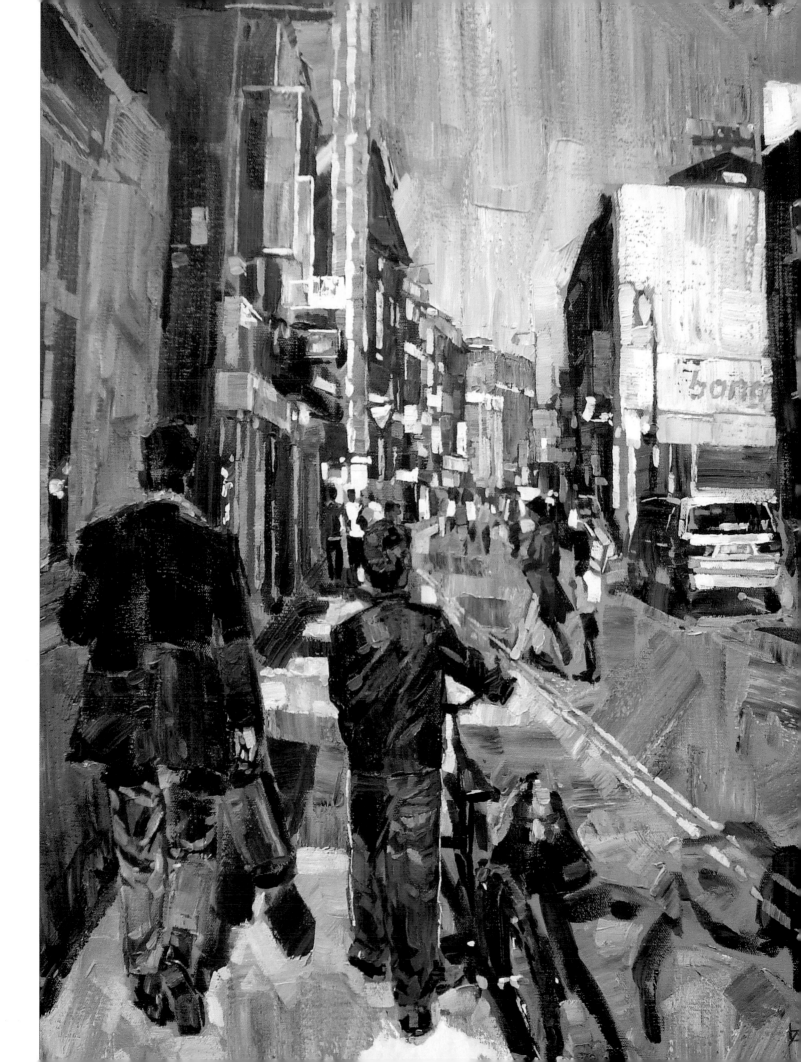

Harmoniously coloured grounds

Harmonious colours sit next to each other on the colour wheel, for example yellow, orange and red, or yellow, green and blue. Other ways of using harmonious colours are to choose just cool colours; only warm colours; or only earthy, muted hues. In every case, due to their similarities to each other, harmonious colours create a sense of balance, order and tranquillity and are pleasing to the eye.

There are numerous occasions when choosing a base colour can be taxing. Optimising the contrast between colours by employing complementary colours can sometimes provide too many options. Do you want to use an orange ground to contrast against a landscape's blue sky, or purple to provide contrast to its yellowish-green fields? Using harmonious shades can be a good compromise. In this example, using a cool yellow base would work well with both the blue sky and green field.

In the painting shown on these pages, the ground is deep violet mixed with a touch of coeruleum blue, softened with titanium white (see the part-worked example below). The buildings and figures were established with rough coeruleum blue outlines, then layers of paint were dragged downwards. Violet is made up from red and blue, and it therefore harmonises with the earthy reds and greens. Small touches of vivid red help to break up areas without being jarring. In the finished painting, the tints in the sky and road contain magenta and dabs of previously applied colours, which helps to maintain the overall sense of balance.

Using a harmoniously coloured ground will provide balance, but it will produce little interest in colour contrasts. As a result, it may be useful to emphasise tonal differences more than you otherwise might – add more detail or use more exuberant brushwork in order to maintain an exciting, interesting impression.

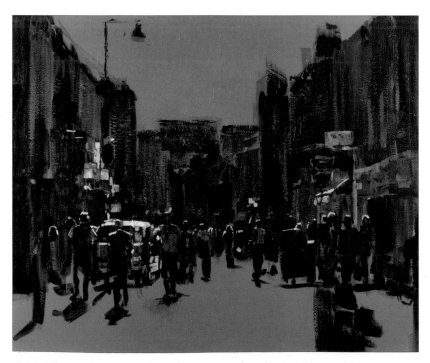

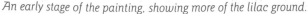

An early stage of the painting, showing more of the lilac ground.

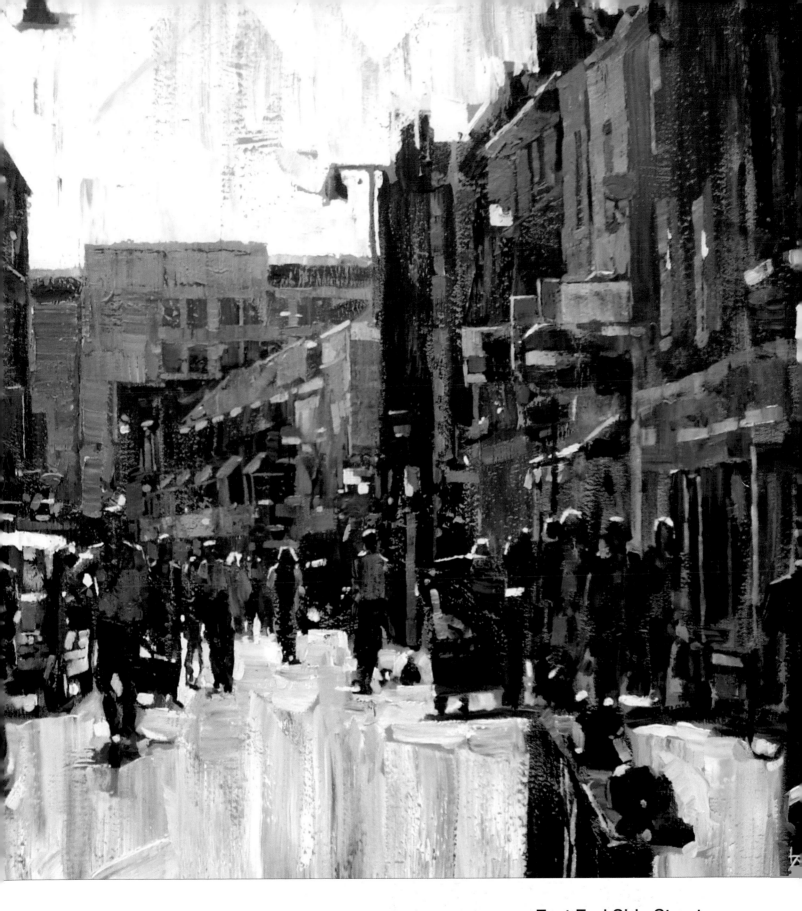

East End Side Street

London's East End is full of streets like this and people going about their business. In this painting the figures are quite set back, which opens more foreground and provides room for the viewer's eye to roam the scene. Sunlight floods the sky and road, framing the building and figures.

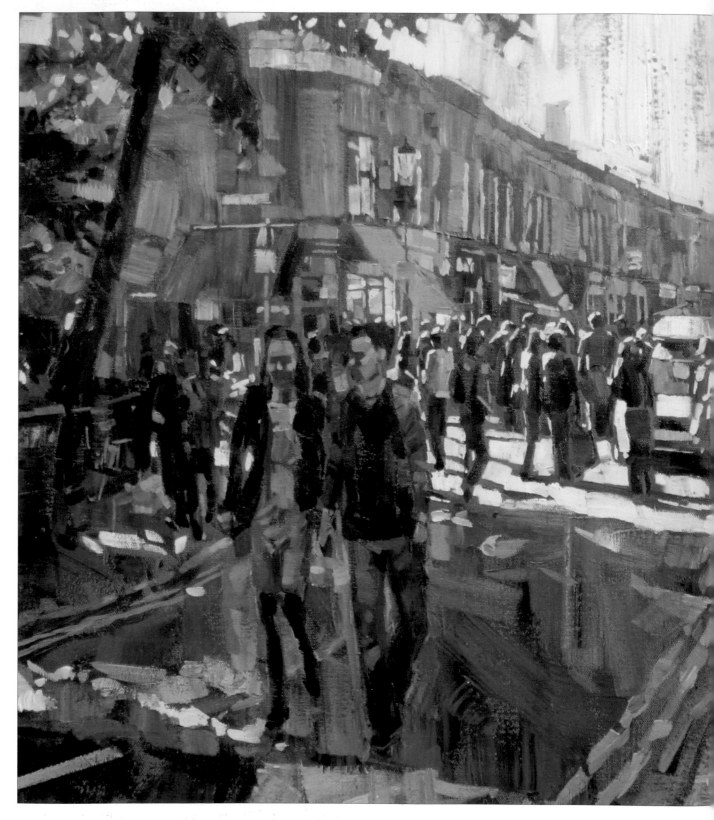

Columbia Road Walk

*Columbia road, in London, has one of the most famous – and busiest –
flower markets in the capital. I wanted to contrast the crowds in the strip of
sunlight against the couple walking off under the cool shade of the trees.*

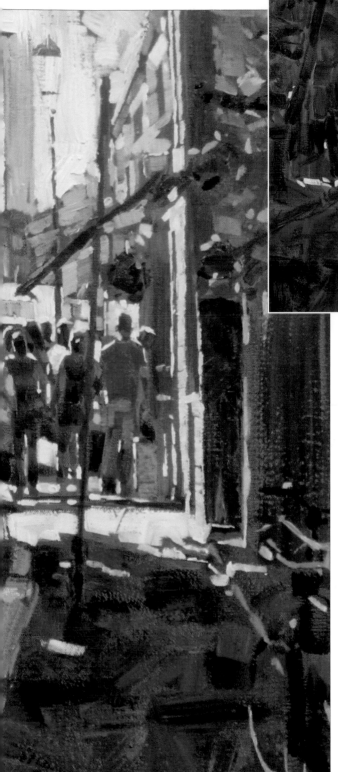

The vivid pink shows through clearly at this early stage.

Bright grounds

Bright grounds will allow you to explore the boundaries of how colours interact when placed side by side or layered. One of the great advantages of using a 'high-octane' ground is that it will lift any muted or earthy shades that you later apply, which means it acts as a useful insurance policy. Painting a grey, rainy landscape can be invigorated with a bright yellow ground; while producing a portrait on a warm or cool bright base can evoke a particular characteristic of the sitter.

Whether you are using muted or bright base colours, it is vital to gauge how the finished painting will look. Too harmonious a combination will mean the viewer will be understimulated and rapidly lose interest. The other extreme is clashing colours which overstimulate, creating a chaotic, confused result.

For the painting on this page I used my favourite base colour; one that seems to work with just about every scene: process magenta with titanium white (see the part-worked example above). The scene contains a large area of shadow in the foreground, so a bright magenta ground maximises the contrast. Magenta contains a hint of blue, so it is less jarring than a strong red would be when set against the blue shadows. In addition, the cadmium yellow highlights appear brighter set against the ground colour because the process magneta base is close to purple, yellow's complementary colour.

Coeruleum blue was used for the initial sketch and swathes of blue, green and burnt sienna were applied to the foreground and shaded areas. Highlights were then added. It is useful to remember that highlights provide more potency on a mid- to dark-toned base, so try not to make the base too pale. The final painting has a cool, calm feeling with the couple walking in the shade and plenty of contrasts to reflect the hustle and bustle of the crowd in bright sunlight.

Timing yourself

Timing yourself at different stages of a painting is a great way of developing discipline and judgement. Most people have no idea when a painting is finished, and the most common observation from my students is 'I have overworked my painting'. It is seldom I hear that a painting is underworked. Stopping every fifteen minutes and taking a step back will force you to consider what, if anything, still needs to be done.

I use to spend months on individual paintings, every brushstroke dragged kicking and screaming to the canvas. By the end of the process I was drained. While this did impart observation and patience to me, I can hardly say I enjoyed my painting – it was more an obsession. Nowadays, I make each and every brushstroke count. Where once I would have used a hundred marks, I now apply one decisive stroke. Think in terms of quality, not quantity!

This painting was executed in fifteen minutes.

Holding the brush

Most beginners hold a brush as they would hold a pen or pencil. This produces a firm grip with plenty of control and a consistent pressure. In painting, inconsistency breathes life into a painting, creating contrasts and expression. Utilising the entire length of a brush as well as different sizes will help to provide a wider range of possibilities.

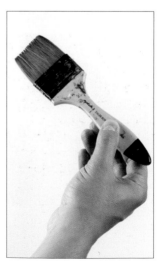

A loose, relaxed hold towards the back of the handle creates a smooth, gliding motion, perfect for initial 'skins' of paint. Utilise your entire arm to keep the stroke smooth.

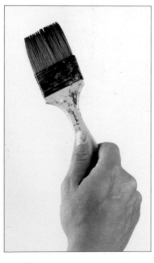

Holding the brush near the back with a firmer grip allows you to apply more pressure to the front part of the bristles: great for blocking in larger objects clearly.

For edging, use the blade of the brush, holding the handle loosely as shown. Do not let the handle rest in your hand.

Hold the brush near the ferrule for controlled details or to lay down thicker layers of paint.

Exercise: Using generous strokes

The marks you make with your brush are another way of showing the viewer what or how you feel about your painting. Broad fluid brushstrokes give an impression of freedom and exuberance. It shows confidence and direction but more importantly enjoyment. In any artwork, indecision stands out like a sore thumb and becomes an area of tension. Overworking paint kills freshness, and no matter how good the drawing might be, the paint will look dull and tired. This exercise shows you how to create a tree with only a few big strokes.

You will need

Brushes: 50mm (2in) Sky Flow, 25mm (1in) short flat

Paint: process magenta, titanium white, phthalo green, sap green, coeruleum blue, cadmium yellow, deep violet, process cyan, lemon yellow

Canvas: 46 x 61cm (18 x 24in)

Water pot

1 Pick up process magenta and titanium white on the 50mm (2in) Sky Flow brush. Dip the loaded brush into the water pot and lay on a ground with loose, generous strokes applied in long strokes in varied directions.

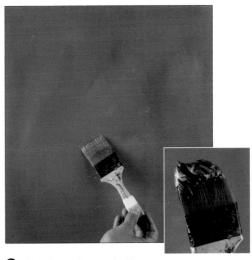

2 Continue to apply the paint until you have built up a smooth ground over the whole canvas. Do not worry about streaks and brush marks on the ground. These add to the texture. Allow the ground to dry thoroughly, then pick up phthalo green, sap green, coeruleum blue and cadmium yellow (see inset).

Tip

Do not clean your brush during these initial stages. Not only does it ensure that the colours blend smoothly because hints of previous colours are included in each new stroke, but it also means that flashes of colours will appear from the core of the paint after the top layers are spread on the surface, adding liveliness to your painting.

3 Begin to lay in the large areas of colour with loose strokes, working vertical and diagonal strokes and reloading your brush when the paint starts to run out.

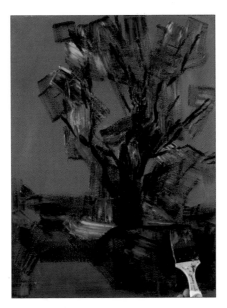

4 Use the same colours with the addition of deep violet to plot the deep shadows and main trunk of the tree. Use the blade of the brush to get strong fine marks.

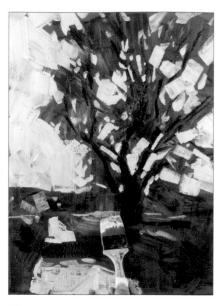

5 Clean your brush, then pick up titanium white with touches of process cyan and cadmium yellow. Use smooth, gliding strokes that utilise the whole head of the brush to block in the large areas of sky.

6 Apply shorter strokes and use only the front third of the bristles for smaller areas such as between the branches. Load the brush with more cadmium yellow when painting the parts near the horizon.

7 Start using smaller areas of the brush to pick out the main pockets of light behind the tree and to create the path. Vary the angles, length and pressure of the brushstrokes to create dynamism. Use the bolder strokes laid in earlier to help guide the angle of your brushstrokes.

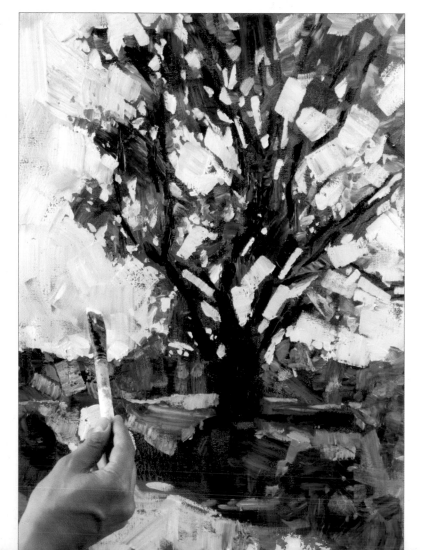

8 Change to a 25mm (1in) short flat brush. Holding the brush roughly halfway down the handle, pick up lemon yellow and titanium white. Add in smaller marks that overlay and break up the larger marks, covering more of the magenta ground so that only hints of the strident contrasting colour remain. Vary the hue with process cyan for interest.

Tip

Try to work instinctively: these small marks are potent, so it is important that they remain abstract and uncontrived.

Opposite:

The finished painting

The painting was completed within fifteen minutes. Working swiftly ensures your work remains fresh, vibrant and bright.

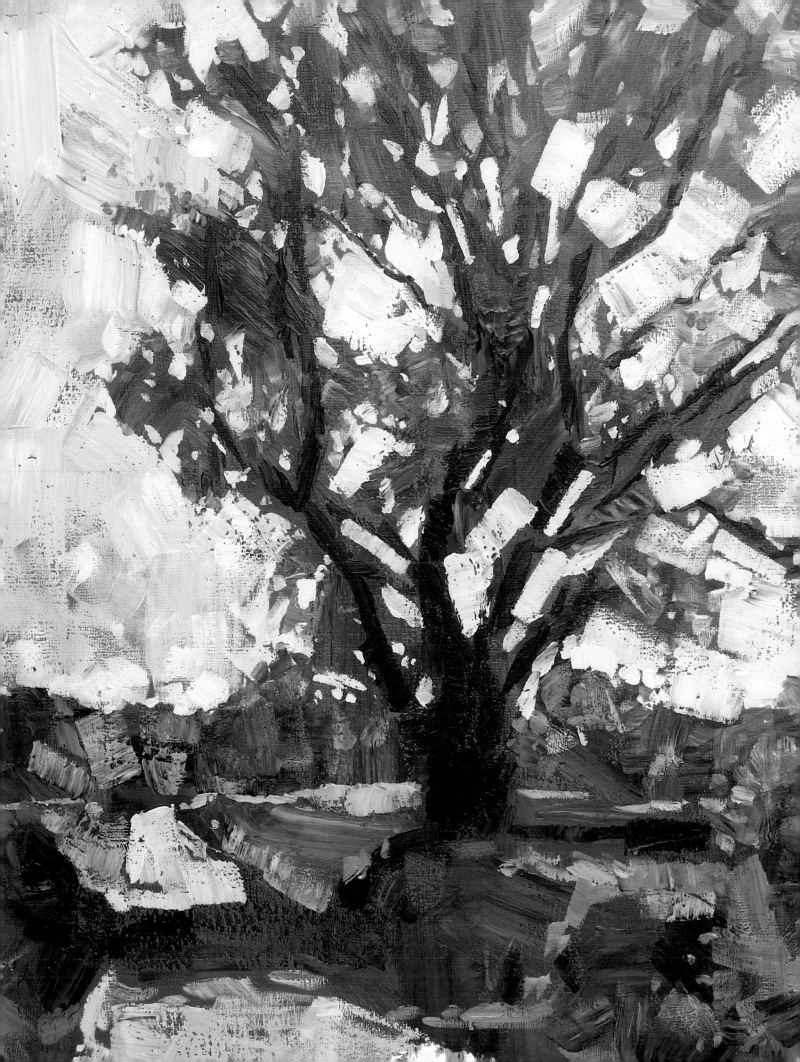

Exercise: Let's paint!

As I mentioned earlier, the best tool for learning to paint is the paint itself. For this exercise, I have chosen an unusual combination of objects, including a foil box containing bell peppers and sliced lemons, and a blue stapler, for a simple still life. The elements were brought together for their colours (strong primaries) more than their relationships as objects. Using the primary colours of red, blue and yellow in close proximity always produces pleasing colour results.

The objects themselves are similar in scale but quite different in nature, transparent, reflective and opaque. With brushes at the ready and canvas primed, let's paint!

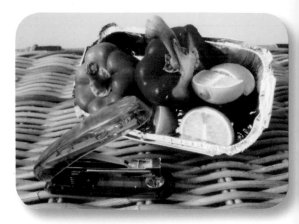

The source photograph for this painting.

You will need

Brushes: 50mm (2in) Sky Flow, 37mm (1½in) Sky Flow, 25mm (1in) short flat, 7mm (¼in) long flat

Paint: cadmium orange, titanium white, process cyan, coeruleum blue, cobalt blue, phthalo green, cadmium yellow, sap green, cadmium red, burnt sienna, yellow ochre, deep violet, lemon yellow

Canvas: 61 x 46cm (24 x 18in)

Water pot

1 Mix cadmium orange with titanium white and use the 50mm (2in) Sky Flow brush to lay in a bright ground. Use plenty of paint for a lush, rich effect. Allow to dry completely before continuing.

2 Load process cyan, coeruleum blue, cobalt blue and phthalo green on the 50mm (2in) Sky Flow brush (see inset) and paint one or two broad diagonal strokes to suggest the top of the stapler at the lower left. Pick up the same colours with the addition of deep violet to paint the lower part of the stapler, scraping most of the paint from the brush.

3 Load more phthalo green on to the brush, along with some cadmium yellow and sap green. Block in the shapes of the green pepper and the stalk of the red pepper with simple strokes.

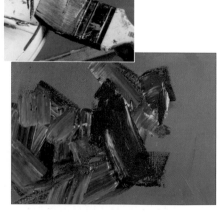

4 Scrape excess paint on to your palette (see inset) and load your brush with cadmium red, cadmium orange, cadmium yellow and a little burnt sienna. Use rich, heavy strokes to suggest the body of the red pepper.

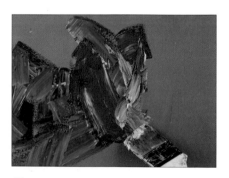

5 Load yellow ochre and cadmium yellow and overlay the paint to bring out the flesh of the red pepper.

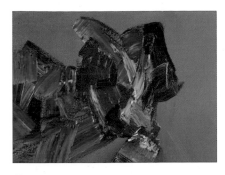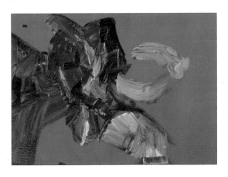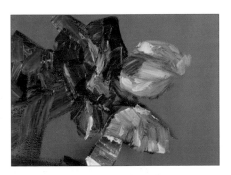

6 Make a deep red for the shaded areas by loading more cadmium red and deep violet. Use more controlled strokes, but continue using rich, buttery mixes.

7 Load cadmium yellow and yellow ochre, but retain some cadmium red and deep violet to show through for shadows. Block in some initial strokes to suggest the lemons.

8 Scrape your brush clean on the side of your palette then reload it with lemon yellow and cadmium yellow. Overlay thick highlights and introduce a little cadmium red to show reflected light from the red pepper.

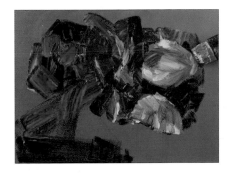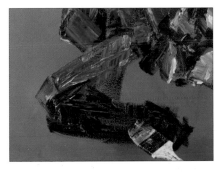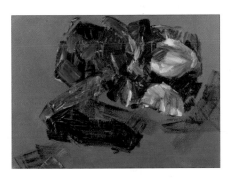

9 Begin to introduce the foil container's shadow using a brush loaded with deep violet and process cyan. Add splash contrasts with hints of coeruleum blue and bring in reflections of the main shapes by picking up touches of the paint scrapings on your palette.

10 Scrape the brush again and add shadows to the stapler with process cyan and deep violet, and highlights with coeruleum blue, cadmium yellow and yellow ochre.

11 Suggest the shadows cast by the various objects with very light strokes of process cyan and coeruleum blue.

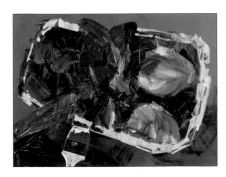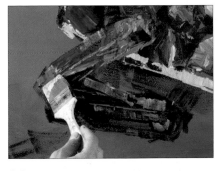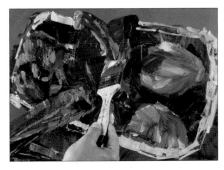

12 Load titanium white and process cyan with a little burnt sienna and cadmium yellow. Using the blade of the brush, strike in lines to suggest the foil container.

13 Add deep violet to the mix on the brush and suggest the metallic parts of the stapler. Pay attention to maintaining the hard, angular lines as you vary the colour. Begin to refine the stapler with highlights of process cyan, titanium white and cadmium yellow.

14 Load your brush with sap green, coeruleum blue, cadmium yellow and plenty of titanium white, and use this to add varied highlights to the green pepper and the stalk of the red pepper.

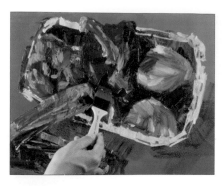

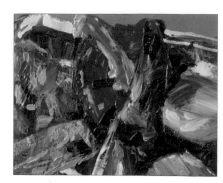

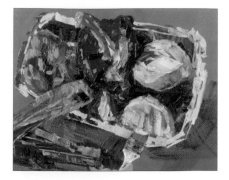

15 Switch to the 37mm (1½in) Sky Flow brush and load it with cadmium red, cadmium orange and cadmium yellow. Develop the body of the red pepper, adding deep violet for strong shading and to refine the structure of the pepper.

16 Use the 25mm (1in) short flat brush to drop in highlights of pure coeruleum blue on the highlight points of the red pepper.

17 Return to the 37mm (1½in) Sky Flow brush. Load it with lemon yellow, cadmium yellow, sap green, titanium white and a little burnt sienna. Begin to refine the lemons and inside of the red pepper. Use hefty loads of paint to create texture and help to ensure coverage.

Tip

In order to ensure the potency of the final highlights, I try not to get tied up in detail at this stage. Keep the strokes expressive by ensuring you hold the brush loosely, allowing it to pivot.

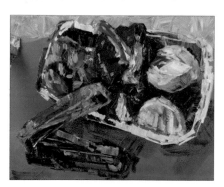

18 Using the 50mm (2in) Sky Flow brush, use a neutral grey made up of titanium white, cobalt blue, coeruelum blue and raw sienna to paint in the background, suggesting a table edge. Vary the direction of your brushstrokes.

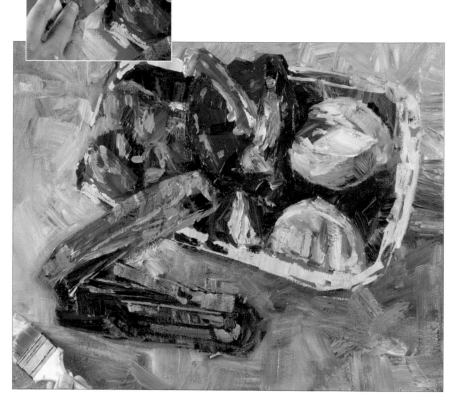

19 Use a contrasting mix of titanium white, burnt sienna, cadmium yellow and sap green to block in the table surface. Add deep violet to deepen the shade on the left-hand side and cut in to cover areas that you have built over, such as the dark area outside the foil container's left side (see inset). Allow to dry completely before continuing.

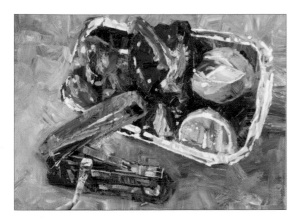

20 Create assertive, controlled highlights with titanium white, lemon yellow and the 25mm (1in) short flat brush. Vary the colour with coeruleum blue for some of the highlights.

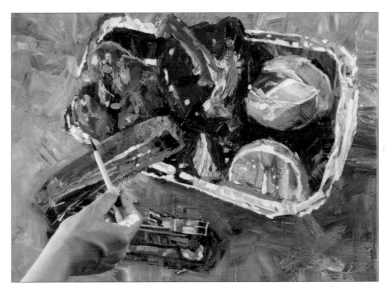

21 Strengthen areas of the objects' outlines with the colours you used for the initial blocking in (see steps 2–12). Finally, use the 7mm (¼in) long flat brush to add touches of pure titanium white as final highlights.

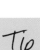
Tip
Use the paint generously so that the paint transfers cleanly to the surface without using too much pressure. It is important that these touches do not blend or merge with the underlying paints: this cleanliness creates the striking contrast.

The finished painting.

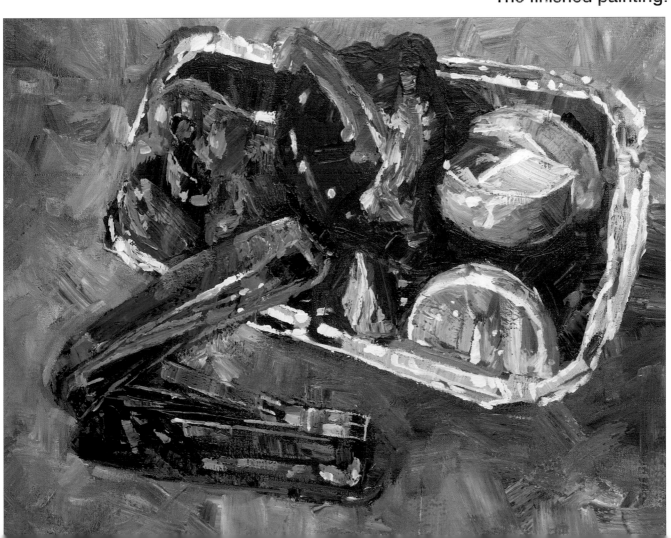

Dramatic composition

If you walk down a busy street, chances are you will be twisting and turning to dodge the crowds, and if you are standing on a boat at sea, you will be rocking from side to side. Replicating movement in such scenes means something a little more dramatic than standard horizontals and verticals.

Creating a sense of movement starts with the composition, and employing something as simple as tilting the camera when taking reference shots can be very effective. More diagonals mean more movement in a composition. Try finding a higher viewpoint or take photographs with the camera held high above your head for the entire story or from a very low viewpoint for a sense of scale.

Try a composition with lots of horizontals and verticals and with one prominent diagonal at the focal point for maximum effect. Too many diagonals may look quite hard to the eyes, so adding a slight curve to corresponding lines creates a more pleasing composition.

Tip

Look out for interesting and dramatic diagonals in potential scenes, it could be a tree leaning over, long shadows leading to the focal point or angular cloud formations.

For calm or tranquil scenes, play down the diagonals and keep everything straight.

Be wilfully contrary

The back end of a bus would not seem to be the obvious choice for a dramatic painting about capturing movement. However, add a slight twist to the viewing angle and anything is possible. The colours, people, reflections and buildings are interesting enough, but sometimes you have to look a little bit closer to find the right clues to make your painting compositionally interesting.

Thinking 'outside of the box' and away from the norm is paramount in discovering original alternatives. You might like to look at how other artists or art movements have tackled composition issues. Japanese prints, for example, use overhead perspectives to tell the whole story, while Cubist paintings often employ multiple angles of the same object in one painting.

If you are going to spend valuable time creating a work of art, try to consider every facet, from inception to final execution.

London Buses
Diagonals equal drama.

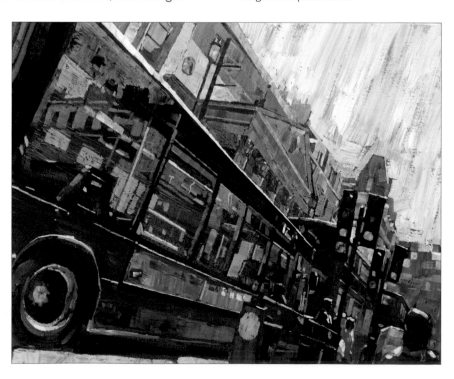

Unusual choices

We all like surprises. Art should hold plenty of them, and avoiding predictability is key. Most traditional subject matter has been painted hundreds of times. Whether floral or botanical art, pet portraits, still life or any of a hundred other traditional subjects; all have heavy expectations from the viewer, which will colour their opinion of the work.

As an artist, this predictability is safe and makes such subjects easy to access, but it lacks originality and may be compared to other, superior versions. Adding a pleasing new twist or rearranging elements of traditional themes in creative ways will elevate your work and can create new trends.

Whatever you are painting, spend a few minutes thinking through the obvious approaches, and see if there is an alternative. Think about unique compositions, contemporary elements and the essence of what you are painting, such as movement in water or heat from sunlight.

Purchasing a specialised brush to paint trees will mean your paintings will look exactly like everyone else who has bought a similar brush. It may be effective in the short term, but the cloud of predictability will eventually descend and the paintings will appear lazy and uninteresting. Learn the basic techniques and then impose your own personal choices to make your paintings stand out.

Study of Fridge Contents

Some of the best choices for paintings are right under your nose – or in this case, in my refrigerator! This study demonstrates that you do not have to look too far for interesting, uncontrived combinations of objects and interesting lighting effects.

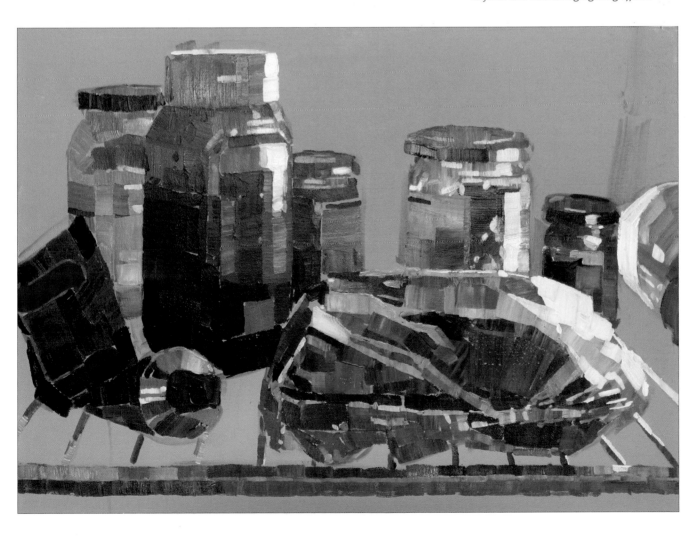

Making decisions

Some artists approach a painting unrestrained by any clinical thought process. Their paintings evolve organically through trial and error until something magical happens. In contrast, I find the key is to be clear about what I want to convey in my work from the start, and concise in how I achieve it. The mechanics of painting will be learnt over time. With experience you become more decisive, and the same is true for preparing your ideas for a painting.

Areas of tension can stand out as fear and insecurity step in. Indecision, frustration and boredom can appear all too clearly through the marks and statements you make with paint. To avoid this, visualise what you want to say or do with your painting, and work out how you will achieve this with the options available. Once you have made these decisions and choices, ensure you are one hundred per cent behind any application of paint. The confidence will shine through and you will naturally develop a stream of positive thinking that leads to great results.

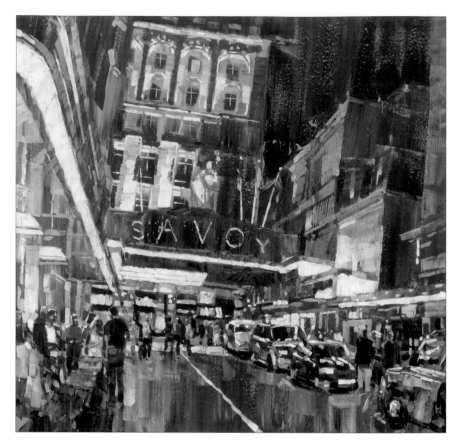

The Savoy

The Savoy at night is a striking London landmark. The bright lights, glamour and excitement, twinned with theatre goers, taxi cabs and tourists coming and going, means this scene cries out to be painted. With so much on show the natural inclination is to paint everything; but choosing an aspect to focus on is crucial to ensure your finished painting is not confusing. The main aspect I decided to convey is the glorious floods of golden light and the contrast they make against the night sky.

I decided the building should take second place to the figures and cars, so the brush marks are quite loose. The tilted camera angle is a compositional decision I use a lot in my street scenes, as it is great for drama and movement. The base colour is a turquoise which keeps things cool and ensures the warm reds are eye-catching.

It is great fun painting strong highlights and this scene has plenty of them. Your eye jumps from one to the other so minimising the quantity is essential. This is one of the best reasons for not using a tiny brush, as it helps you resist the temptation to do more and more. Sometimes your decision making processes can be clouded, so utilising certain brushes or time constraints are great ways of keeping the discipline.

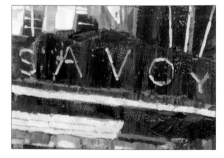

I am always wary about adding type in any painting as it will need to be read, which can draw the viewer's eye away from the focal points. However, in this case the letters are subtle and form an important part of the iconic image of the Savoy, so I felt they had to be included.

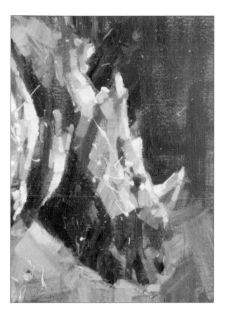 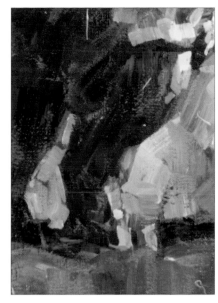

I used quite blocky, painterly marks overall, with minimal fine details on the face. I am always conscious not to overplay detail with animals. I have seen plenty of paintings and drawings which replicate everything, to the extent that the painting becomes a exercise in technical ability rather than conveying character or emotion.

An early decision was to use a cool base colour, flecks of which would show through at the end. This would show up nicely against the warm ochre colours and help to unify the painting. Four or five definitive marks are enough to show light striking the rhino's leg, while the background is lifted with lighter tints to draw the shapes out.

I used spattering in this painting – in fact, more like dolloping, as the paint was quite thick in certain areas. Most was applied to the rhino's back: I thought this would create a certain wildness in the application of paint to reflect the essence of the animal. I also made the decision this should be the focal point. I loved the bone structure with the ribs coming through and it makes a change not featuring the head as the focus.

Rhino

This painting is based on a photograph I took at Colchester Zoo where this amazing beast was happily posing. To see the structure, weight and sheer presence of such an animal up close is awe-inspiring. There were a couple of other rhinos behind this one and more of the zoo enclosure but it was enough to show the individual.

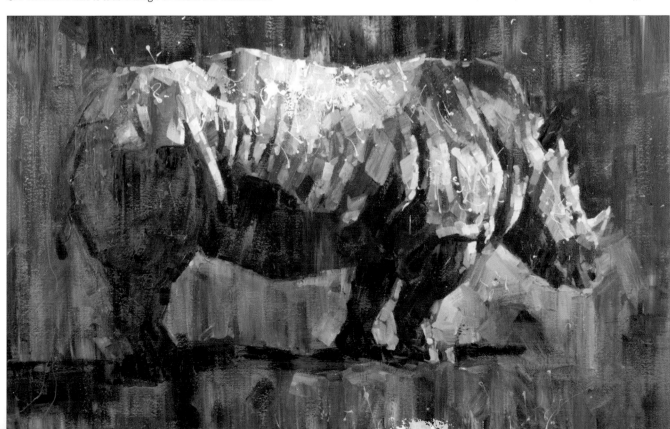

Tone and colour

Adding colour sparks paintings to life, helping to create moods, which can in turn bring about emotional responses from the viewer. Tone is important in creating three-dimensional effects, and hue tugs deep at our emotions. Balancing the two in a painting can be challenging, as the two aspects of colour will fight for dominance. Ensuring they work together to create a harmonious scene requires experience, and to do so, it is important to understand how colour works.

Tone and hue

These aspects of colour should be your first consideration as they provide the technical basis from which to work. Simply put, hue is the specific colour – red, blue, green etc. – while tone is the relative lightness or darkness of the hue.

Darkening a hue creates shades, while tints are created by lightening the hue. Understanding the effects of light on objects and the resulting changes in tone this causes will provide a natural realism to your painting. Paint hues can be darkened by adding black or darker paints, creating shades of the original colour; and lightened with white or lighter paints, creating tints of the original colour.

Every colour can produce a range of shade or tone and how light or dark these are depends on the colour. Lighter colours, such as lemon yellow, will produce a smaller range than darker colours, like deep violet.

Starting from a midtone

Applying a midtone colour to your surface establishes a base to work from, and I recommend never starting on a pure white canvas – even a very pale tint is better than stark white. Working off white means you are starting with your most extreme highlight. You will have more work to do in applying the midtones, and darks and even at the end, more highlights will have to be applied.

The colours you initially apply (including the base colour) work best if they are midtone rather than anything too light or too dark, because they provide options – you can work lighter or darker as you progress through the painting, rather than being forced to do one or the other.

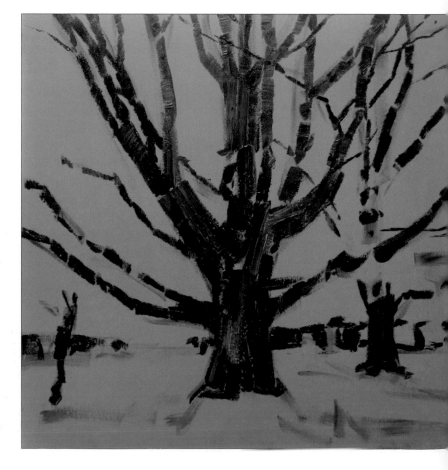

A combination of coeruleum blue and phthalo green, with titanium white added to soften the colour, has been used to create a midtoned ground. Mid to dark tones are applied for the tree trunk and branches to create a strong, dominant shape. Both the background and tree can be easily tinted or shaded later.

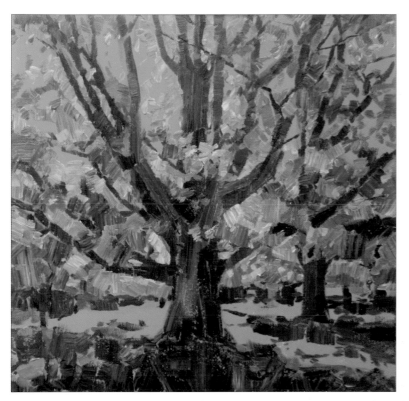

Tints and shades

Adding white is the easiest way to lighten a colour but may subdue the intensity, so try lightening colours by adding another colour of a lighter value. For example, use light yellow to tint warm colours and coeruleum blue to tint darker, cooler colours. Yellow ochre can also be useful for this as its opaque nature allows it to soften colour of a darker shade. Use it sparingly as this colour can overwhelm and dominate other colours of paint.

I never use black paint in my colour paintings, as this extreme shade absorbs and flattens other colours. For a potent dark try mixing dark blues, violets and dark greens. Overmixing the colours together on your palette can flatten them out and make them dull, so load your brush with each pure colour and leave the mixing for the canvas (see page 27 for more on loading your brush).

Rich tints of colour have been applied with absolutely no white added. These tints were created using lighter colours including lemon yellow, cadmium yellow and yellow ochre.

White

White is your most extreme tint and needs to be used sparingly. In an instant you can draw the eye with even the smallest application of pure white.

Using dominating pigments in your palette means even a touch of that colour mixed with white can produce a variety of contrasting colours. Minute amounts of process cyan, process magenta or phthalo green added to titanium white will give luminous tints.

The application of pure titanium white is therefore the final stage in any of my paintings. These are small dabs and even at this stage a fraction of lemon yellow is applied to warm the colour. In certain circumstances, you might like to add more colour to the white for variation.

Autumn Tree

Tones create depth and colours create mood. With the initial highlights in place (see above), it was easier to judge where the final highlights worked best to produce a well-balanced painting.

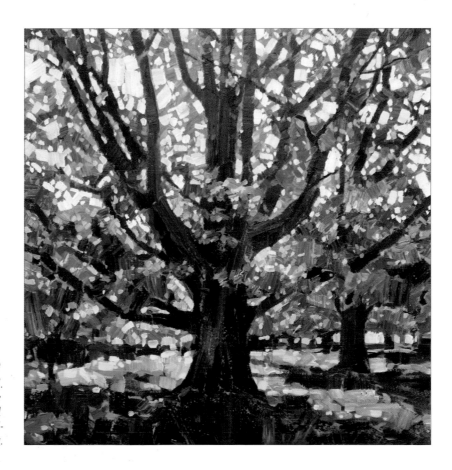

Exercise: Resisting white

White and black lie at the extremes of the range of tonal values, so use them sparingly. I only ever use pure black in my monotone paintings; and while pure white is used in all of my paintings, it is only used once I feel I have exhausted the range of highlights I can achieve with colour.

To get the full potential of white in your paintings, tint your colours with tiny amounts of white for your initial highlights. For the brighter highlights, go for assertive amounts of white and add touches of lemon yellow. The addition of yellow will spark the highlight to life and ensure you do not get the flat, chalky impression of highlighting with white alone. It is worth experimenting with small shots of other colours in white, as these pigments produce subtle tints of magic.

This exercise shows how you can create a vivid, atmospheric painting of a white subject without using too much pure white. The end result should be strong and the final highlights very obvious.

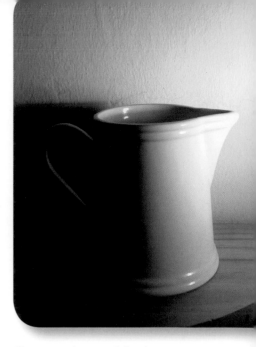

The source photograph for this painting.

You will need

Brushes: 50mm (2in) Sky Flow, 25mm (1in) short flat

Paint: yellow ochre, sap green, deep violet, cadmium yellow, burnt sienna, titanium white, lemon yellow

Canvas: 30 x 46cm (12 x 18in)

Water pot

1 Take the 50mm (2in) Sky Flow brush and load it with yellow ochre and sap green. Use long vertical strokes to fill the canvas, adding deep violet on the left, and both deep violet and cadmium yellow on the right.

2 Load the brush with sap green and yellow ochre, then add near-vertical strokes to suggest the light catching the right-hand side of the jug and details of the handle. Use the remaining paint to quickly create texture and light above the jug, then load burnt sienna to the brush and lay in the table surface with horizontal strokes.

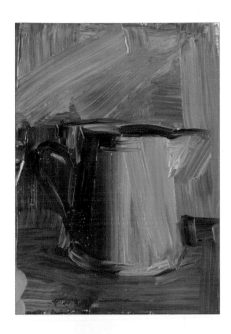

3 Without cleaning your brush, pick up deep violet and add shading to the left-hand side, inside and other shaded areas of the jug.

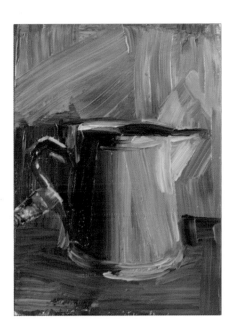

4 Mix titanium white with cadmium yellow and yellow ochre, and use the 25mm (1in) short flat brush to add highlights. Contrast the existing brushstrokes by working in the opposite direction to those previously applied.

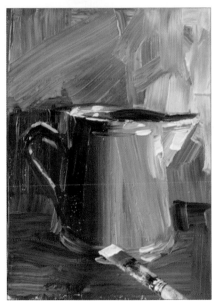

5 Add a little lemon yellow to titanium white, and apply small but thick touches of paint as final highlights.

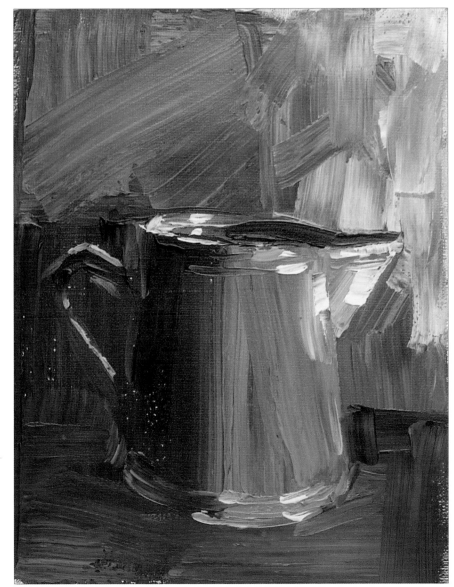

The finished painting

The range of tones and minimal use of colour leads the eye neatly to the defining lines and highlights. Less is more: in most cases artists strive for directness and simplicity.

Building up your skills

The source photograph for this painting.

Exercise: Paint a flower in fifty brushstrokes

The consideration given to each brushstroke is a discipline worth mastering, as you will become more assertive and less fussy. Why use ten brushstrokes when you only need one?

This speedy exercise will show what you can achieve with the most limited of brushstrokes. Each mark has an important statement to make and by over-cluttering the scene you will lose the strong assertive statement you wish to make.

You will need

Brushes: 50mm (2in) Sky Flow, 25mm (1in) short flat, 7mm (¼in) long flat

Paint: sap green, burnt sienna, coeruleum blue, cadmium red, process magenta, cadmium yellow, titanium white, deep violet, process cyan

Canvas: 30 x 45cm (12 x 18in)

Water pot

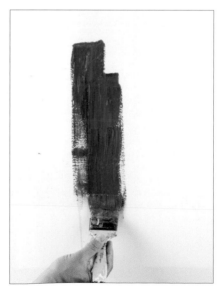

1 Make two or three bold vertical strokes in the centre of the canvas, using the 50mm (2in) Sky Flow brush loaded with sap green, burnt sienna and coeruleum blue.

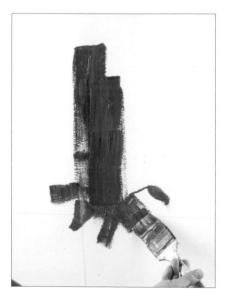

2 Make a few basic leaves with the same mix, using shorter strokes at various different angles.

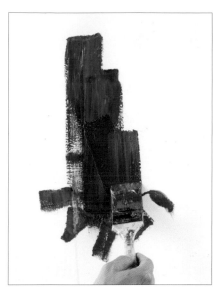

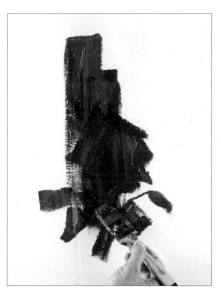

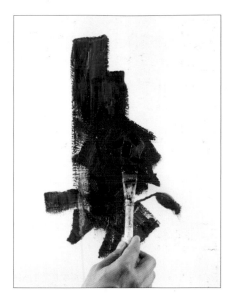

3 Switch to a clean 50mm (2in) Sky Flow brush and load it with cadmium red, process magenta and cadmium yellow. Make a bold stroke on the lower right of the green area. Add a little titanium white and overlay the red with a slightly offset second stroke.

4 Make half-a-dozen overlapping strokes with the same colours. Create some smaller triangular touches by using different parts of the brush.

5 Load a 25mm (1in) short flat brush with deep violet and process cyan. Use a dozen short strokes to pick out some darker areas. Vary the hue with cadmium red.

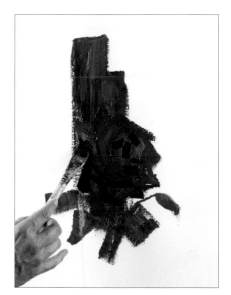

6 Use the same colours to add the shaded parts of the petals by drawing half-a-dozen strokes that abut the triangular marks made earlier.

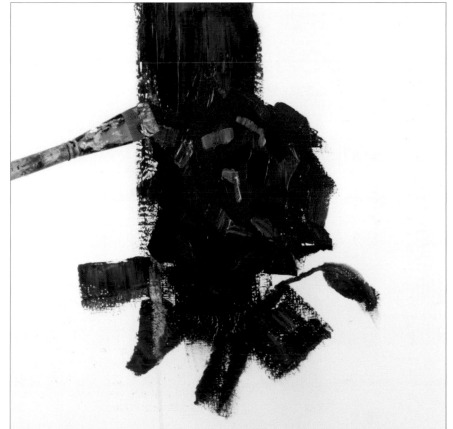

7 Introduce highlights with titanium white and cadmium red, partially overlaying and connecting the earlier strokes.

STILL LIFE

It is difficult to escape images of wine bottles and bowls of fruit when thinking of still life. However, even a staid still life like a bowl of cherries can create an intriguing and personalised scene when juxtaposed with more unusual everyday objects such as mobile phones or a set of keys.

When choosing objects for a still life try to opt for elements with contrasting features. Vary the sizes, colours, tone, textures and even how they are related. You might want a composition based on only one theme, such as foodstuffs or metallic objects.

In terms of composition, it is useful to look for strong geometric shapes on which to base still life paintings. Elements forming a triangular composition work extremely well; as do large objects placed behind smaller, longer foreground objects. Circle-shaped compositions work to draw the eye rhythmically round a painting. It is also a good idea to use odd numbers of elements for your still life rather than even numbers. The brain tends to match pairs up and works that little bit harder to work out odd numbers of objects.

A strong light source, like a spotlight, will reflect off and interact with brightly coloured objects, creating interesting colour mixes.

Kitchen Drawer

Potentially anything you come across can make an interesting painting, even something as innocuous as a drawer full of kitchen utensils. The everyday nature of such objects can often create pleasing and spontaneous compositions. In this painting, the light glinting off the metal objects lifts the shapes and creates interesting focal points.

Antiques and Tennis Ball

The majority of the objects in this still life are closely associated with home furnishings: a wooden mirror frame, metallic telephone and ornamental lion. The main function of these elements is to contrast with one another to varying degrees, so their shapes are distinctly different, tall, decorative and hard-edged.

The fluorescent tennis ball is very much the outsider, in terms of shape, function and colour. This stark contrast with the other elements creates interest and makes it an important focal point.

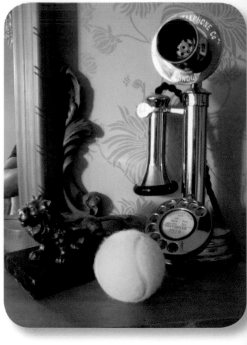

The source photograph for this painting.

You will need

Brushes: 50mm (2in) Sky Flow, 25mm (1in) short flat, 37mm (1½in) Sky Flow, 7mm (¼in) long flat

Paint: sap green, cadmium yellow, titanium white, process magenta, process cyan, coeruleum blue, burnt sienna, deep violet, yellow ochre, phthalo green, lemon yellow

Canvas: 46 x 61cm (18 x 24in)

Water pot

1 Mix plenty of sap green, cadmium yellow and titanium white together on your palette, and lay in a ground on the canvas with the 50mm (2in) Sky Flow brush.

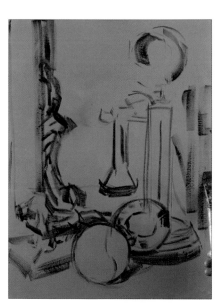

2 Allow to dry, then draw a few light outlining strokes of process magenta with the 25mm (1in) short flat brush to suggest the main shapes and establish the proportions of the objects.

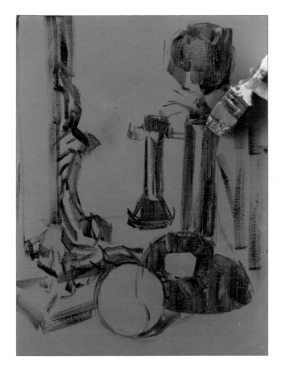

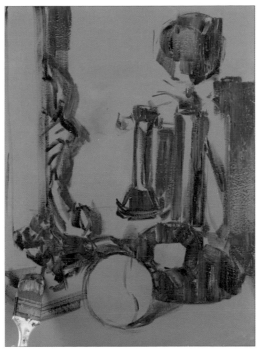

3 Load a 50mm (2in) Sky Flow brush with process cyan, coeruleum blue, cadmium yellow, burnt sienna and sap green. This will produce a deep, lively grey-blue. Apply it to the telephone, using the lines of the initial drawing to guide your brushstrokes: broad and short for rounded areas, narrow and long for the body and earpiece.

4 Fill in areas of shadow with the same colours. Using the same mix across different parts of the painting helps to bind the parts of the painting together as a coherent whole.

5 Integrate burnt sienna and deep violet when reloading the brush, and build up the pedestal and the darkest areas, such as the telephone's cable, mouthpiece and earpiece, and the recesses in the mirror's frame.

Tip
Green and purple work well together visually, so the darks of the painting give vibrancy on the green ground.

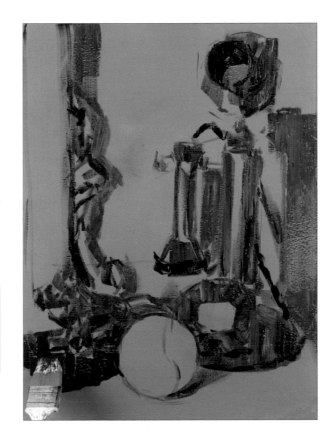

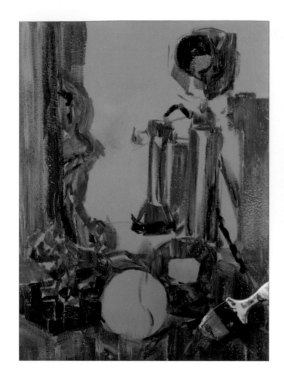

6 Load more burnt sienna, yellow ochre, cadmium yellow and sap green on to the brush and use bold strokes to build up the table surface and frame of the mirror.

7 Add touches of the same brown colour on to the reflective areas of the telephone and the lion statuette at the bottom left.

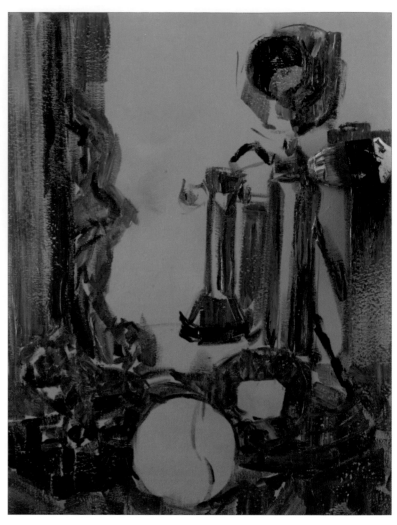

Tip
Because reflections are very close in colour to the objects being reflected, it is best to add them as you work than come back and try to replicate the mixes.

8 Do not clean the brush. Load it with yellow ochre, burnt sienna and a little deep violet, then use fleeting strokes to develop the background a little. You are aiming to just pick up the texture of the canvas, so work very lightly.

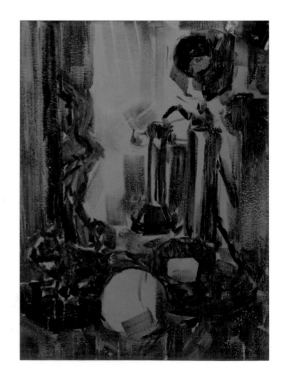

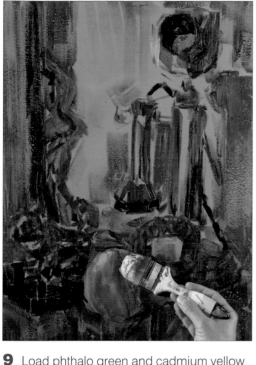

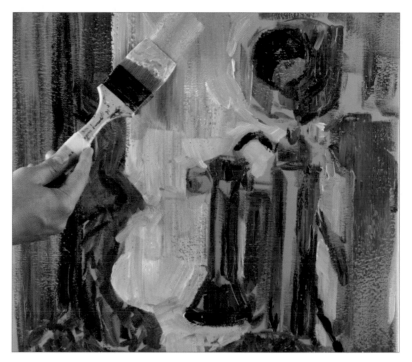

9 Load phthalo green and cadmium yellow on to the brush and lay in the colour on the tennis ball, using more yellow on the top right where the light hits it. Add reflections from the ball to the statuette and telephone with the paint remaining on your brush.

10 Develop the background using the 50mm (2in) Sky Flow brush loaded with plenty of titanium white, burnt sienna, cadmium yellow and sap green. Start from the lower central part, working in long vertical strokes and shorter diagonals for tighter areas; adding more sap green as you work upwards.

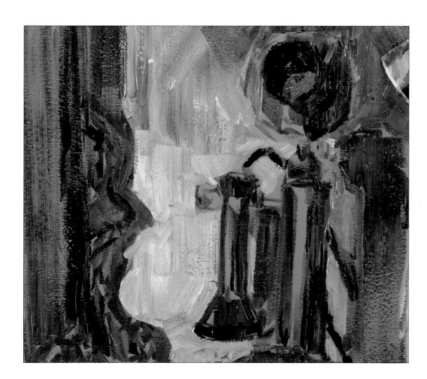

11 Add more deep violet and phthalo green to develop softer shadows on the right of the telephone and mirror frame. Be careful to leave some of the earlier layers of shadow.

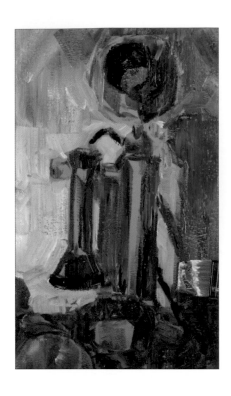

12 Add more deep violet and phthalo green to develop softer shadows on the right of the telephone and frame. Be careful to leave some of the earlier layers of shadow.

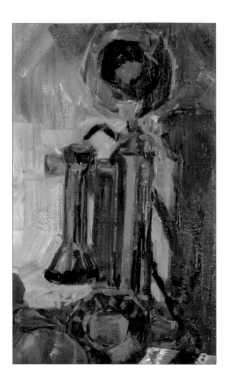

13 Pick up coeruleum blue, cadmium yellow and titanium white on the same brush, and use the edge to apply it to the body of the telephone as shown, using short strokes. Add touches of process magenta to help add interest to this cool area.

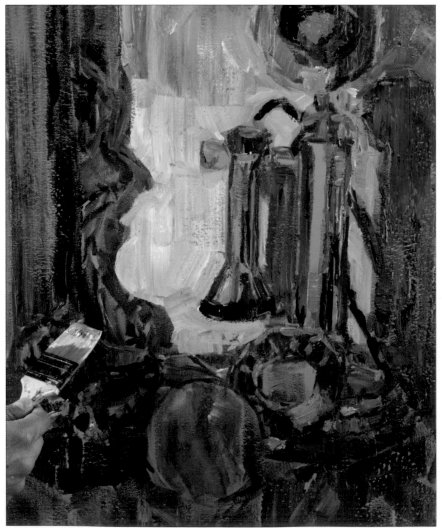

14 Reload the brush with the same colours plus sap green. Applying the paint with the corner of the brush, develop subtle highlights on the statuette in the lower left.

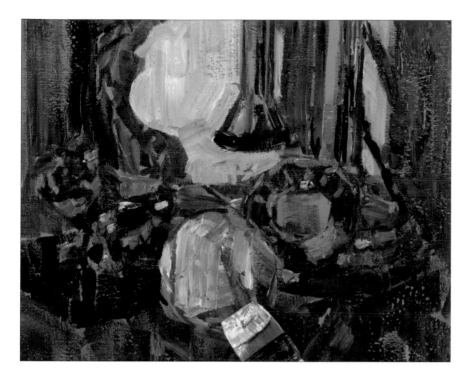

15 Scrape away excess paint on the side of your palette, then load lemon yellow with a little coeruleum blue and build up texture on the tennis ball, using short strokes that loosely follow the shape. Add increasing amounts of deep violet to shade the lower right-hand side.

16 Change to a clean 50mm (2in) Sky Flow brush and load it with burnt sienna, yellow ochre, cadmium yellow and sap green. Use short strokes to give body and texture to the mirror frame, and longer, smoother strokes to develop the table surface.

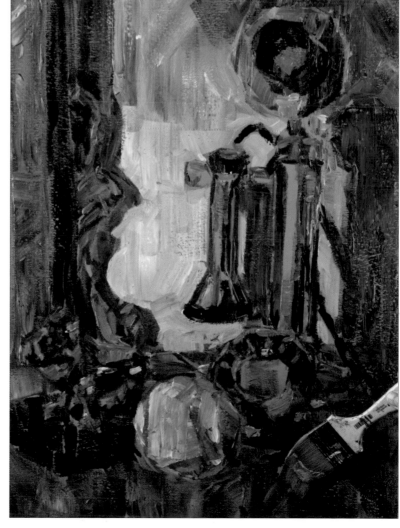

17 Add a few strong punctuating marks across the painting using process magenta and burnt sienna and the 25mm (1in) short flat.

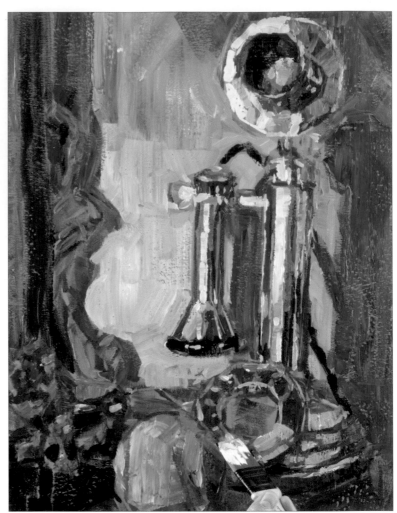

Tip

When painting reflective metal areas, such as the telephone, ensure that the contrast between the highlights and shades is marked. Be confident in the application of the highlights in order to create the impression of a very stark reflective surface.

18 Using a 37mm (1½in) Sky Flow brush with plenty of titanium white along with small amounts of lemon yellow and process cyan, add strong light areas to the telephone. Vary the proportions of the colours as you reload, saving the lightest tints for the strongest highlights. Integrate some of the colours used across the painting in the reflections, particularly on the bottom part of the telephone.

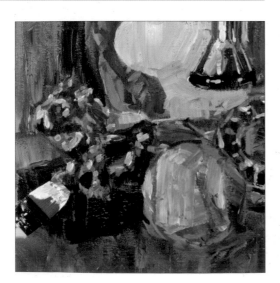

19 Reload with the same colours, adding a touch of burnt sienna to mute the paint slightly, and develop the lion statuette using the corner of the brush.

Tip

It is important that the telephone remains the focal point, so ensure that the statuette has a slightly smaller tonal range (i.e. the darks are slightly lighter and the highlights slightly darker) than the telephone, in order that the lion statuette does not draw the eye too much.

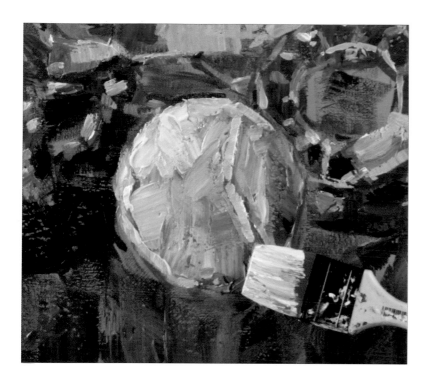

20 Detail the tennis ball using lemon yellow, cadmium yellow, phthalo green and a hint of burnt sienna. Do not try and create a perfect circle: use different directional strokes for texture, and hint at the outline with occasional touches of the blade of the brush. Add the seam using the same colours as the highlights on the statuette.

21 Pick up yellow ochre, sap green, burnt sienna, cadmium yellow and titanium white on a clean 50mm (2in) Sky Flow brush and use subtle touches to add detail to the mirror frame and integrate the different areas of colour on it. Do not aim for perfect lines: variety adds dynamism and character.

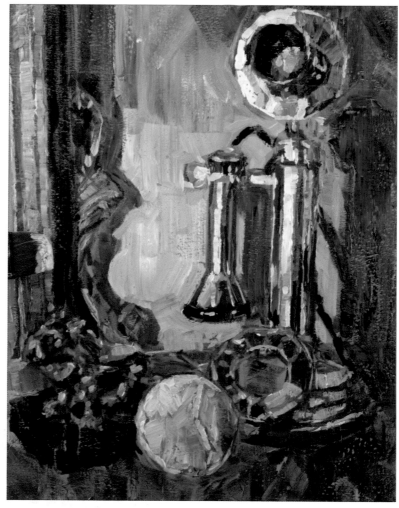

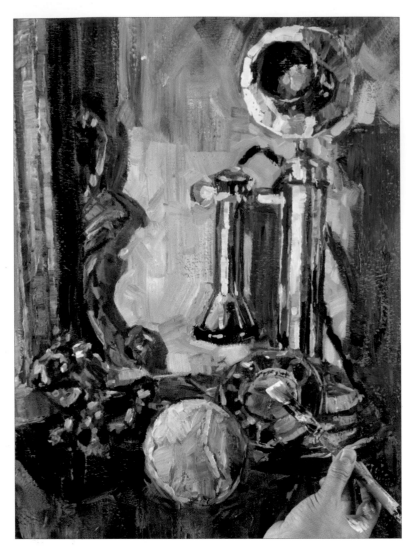

22 Lighten the table surface with the same mix (yellow ochre, sap green, burnt sienna, cadmium yellow and titanium white), then switch to the 25mm (1in) short flat and load it with cadmium yellow, burnt sienna, sap green and plenty of titanium white. Tease out the background with short strokes to add interest and help to shape the foreground objects. Add coeruleum blue nearer the top of the painting and yellow ochre for the frame. Use yellow ochre, coeruleum blue and cadmium red for the centre of the telephone dial.

23 Add some final highlights of titanium white and lemon yellow with the 7mm (¼in) long flat.

Opposite:
The finished painting
At first glance, the finished painting looks fairly traditional in terms of subject and execution. However, the inclusion of an unusual element – the tennis ball – encourages the viewer to question the connection and relationship it has with the other elements. The consideration given to working out the relationships is enough to create a connection with the viewer, which helps to create an interesting, engaging painting.

ANIMALS

People like painting animals, particularly their pets. Unfortunately, the tendency for beginners is to paint them fussily, with extreme detail. Tigers, wolves, elephants, dogs and cats are replicated using tiny brushes and very controlled brush work, which reduces the impact and robs them of the nature that makes them so appealing as subjects.

When painting animals, try to avoid humanising them by 'fluffing' them up or obsessing about every strand of fur. Animals – including pets – are instinctively wild, so the painting should reflect this. Unleash your wild side and use broader brushstrokes. Leave defining strokes until the end and reserve them for the eyes and facial features. The essence of the subject should always outweigh the technique.

Colchester Wolf

I took several photos of the wolf pack, but this individual had that little extra something. He had just woken up and was a bit shaky on his feet, and the sun seemed to hurt his eyes. For such a fierce predator to appear vulnerable was appealing and contradicted the usual majestic stereotype.

Benny

When I began my career as an artist I painted lots of animal portraits. It was good experience, but many commissions ended up as glorified photographs. To avoid this, the memories and experiences with the animal should be considered, as well as a likeness.

Painting memories is an abstract concept but using free and easy brushstrokes and rich colour are practical ways to get this impression across. Photographs will only give you the two-dimensional image, so exert your imagination to create something more intimate.

The source photograph for this painting.

You will need

Brushes: 50mm (2in) Sky Flow, 37mm (1½in) Sky Flow, 25mm (1in) short flat, 7mm (¼in) long flat

Paint: cobalt blue, titanium white, burnt sienna, process magenta, yellow ochre, sap green, process cyan, deep violet, cadmium yellow, coeruleum blue, phthalo green, lemon yellow, cadmium red

Canvas: 46 x 61cm (18 x 24in)

Water pot

1 With cobalt blue, titanium white and a touch of burnt sienna, use the 50mm (2in) Sky Flow brush to cover the canvas with a ground.

2 Using process magenta, make a few strokes with the blade of the 50mm (2in) Sky Flow brush to establish the basic shapes of the figure. Use light, loose strokes to suggest important areas of fur.

3 Load burnt sienna, yellow ochre, sap green, process cyan and deep violet on to the brush. Pull brushstrokes decisively out from the centre of the face and main features on the left-hand side of the face.

4 Work the right-hand side of the face using the same techniques, drawing the paint out from the main features so the brushstrokes radiate from the centre of the canvas.

5 Add some cobalt blue for variety and adjust both sides to your taste, then load yellow ochre and burnt sienna on the brush for the area around the eyes. These warm, light tones will draw the eye to these important areas.

6 Load your brush with lighter colours: yellow ochre, burnt sienna, cadmium yellow and coeruleum blue, and paint in the chin area. Use short, choppy strokes that follow the direction of the fur to create texture.

7 Pick up deep violet along with the other colours when you reload your brush. Use slightly broader strokes of this deeper colour to paint in the transition between the neck and body at the bottom. Make the brushstrokes follow the line of the fur.

8 With process cyan, deep violet and phthalo green loaded heavily on the brush, apply thick textural strokes along the body, in the mouth and around the eyes. Put the brush to one side, but do not clean it.

9 Paint the nose. Use process magenta, cadmium yellow and burnt sienna with a clean 37mm (1½in) Sky Flow brush. Add a few flecks of the same colour around the top of the mouth, then load deep violet and burnt sienna to paint the nostrils.

10 The eyes are an important focal point. Use the 25mm (1in) short flat with phthalo green, coeruleum blue, cadmium yellow and burnt sienna to give a basic hue to them.

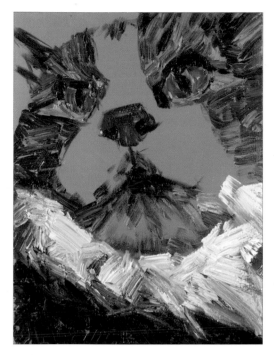

11 Pick up the 50mm (2in) Sky Flow brush you set to one side in step 8, and load it further with titanium white, cadmium yellow, process cyan and a little burnt sienna. Work the fluffy white fur at the neck, describing the texture of the fur with fairly long but choppy strokes that run from the left-hand side to the right.

12 Load titanium white and process cyan with a little cadmium yellow and deep violet to your brush and build up the fur to the left of, and above, the nose. Vary the angle of the strokes, but have the majority angled away from the nose.

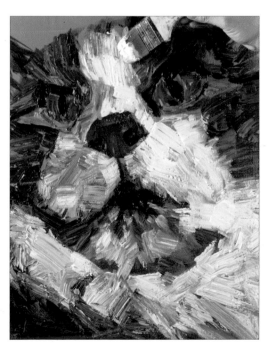

13 Load titanium white, process cyan and process magenta and build up the light fur area near the mouth. Pick up a little cadmium yellow for the fur below the mouth.

14 Load more titanium white and a little lemon yellow for the white fur in direct light on the right-hand side and above the nose.

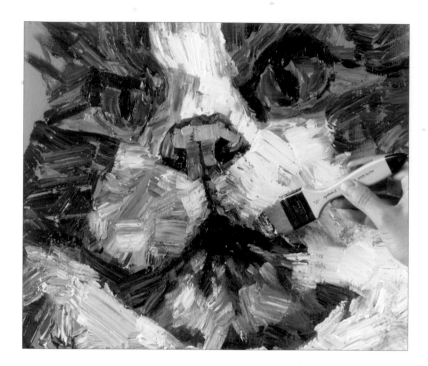

15 Highlight the nose by loading titanium white, process magenta and small touches of both burnt sienna and cadmium red. Use short, fairly controlled strokes to bring out the shaping as shown. Use the paint remaining on the brush to pick out some flecks around the mouth, applying the paint lightly with the edge of the paintbrush.

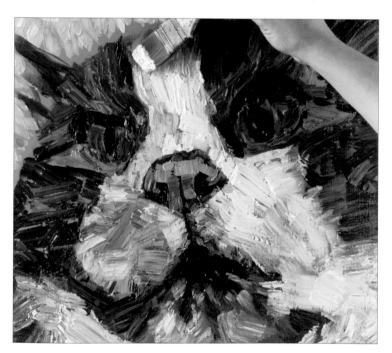

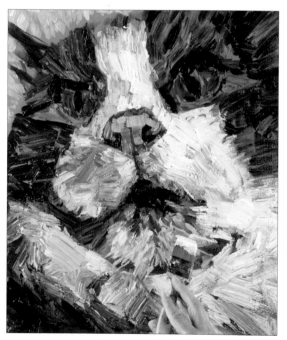

16 With the 37mm (1½in) Sky Flow brush and a combination of process cyan and titanium white with touches of lemon yellow, develop the background in the top left with short, punchy strokes to echo the fluffiness of the fur. Introduce the same colour in subtle touches on the fur, concentrating on the transitions between the light and dark areas of fur.

17 Add cadmium yellow when reloading the brush for the slightly shaded fur of the area beneath the mouth. Use the edge of the brush to help suggest the texture of the fur.

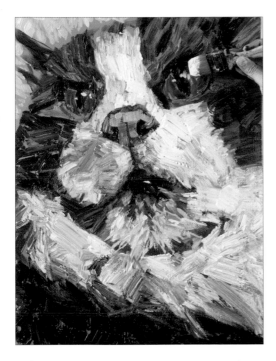

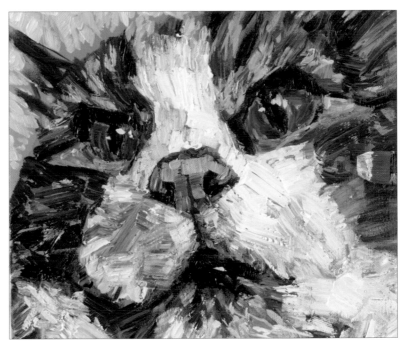

18 Use a mix of titanium white, process cyan and cadmium yellow to add highlights in the eyes and mouth. Use tiny touches applied with the corner of the brush.

19 Do not clean the brush. Pick up titanium white, cadmium yellow and coeruleum blue for a light mix. Use the edge of the brush to add highlights to the area around the eyes with deft touches of the edge of the 37mm (1½in) Sky Flow brush. These flecks of light continue to build up the texture of the fur.

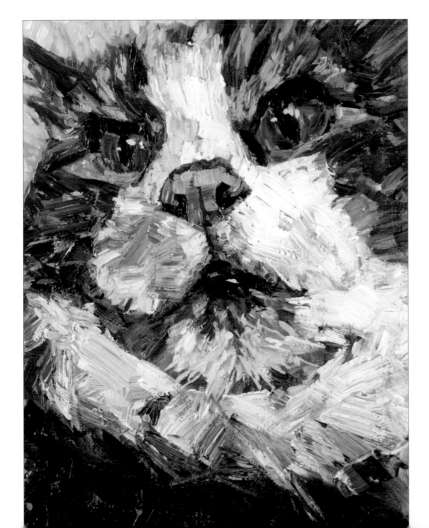

20 Add some deep violet when reloading the brush and add dark areas in the fur around the mouth, ears and the dark fur of the body.

21 With a 25mm (1in) short flat brush loaded with titanium white, lemon yellow, coeruleum blue and phthalo green, soften the eyes by adding small touches that eradicate some of the harder marks made earlier. Vary the proportions, adding more lemon yellow and titanium white for highlight areas and more phthalo green for the darker areas.

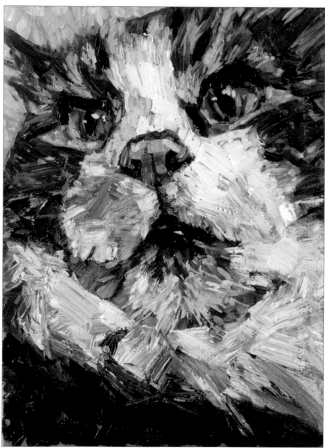

23 Load titanium white and lemon yellow on the 25mm (1in) short flat brush. Use the blade of the brush to add in some final strokes of longer hair on the fur. Add whiskers with the same mix and techniques, using the 7mm (¼in) long flat brush.

22 Soften the transition between the light and dark areas of fur with midtones made up of titanium white, deep violet and burnt sienna. Repeat around the eyes with titanium white, cadmium yellow and burnt sienna; and around the nose with titanium white, deep violet, burnt sienna and process magenta.

Opposite:
The finished painting

Benny was my cat and I have many happy memories of him. He was extremely fluffy but rather than draw every line of fur, it made more sense to use large brushes and streak multiple colours through them. The drags of fresh paint give an effective impression of the big ball of fluff that he was.

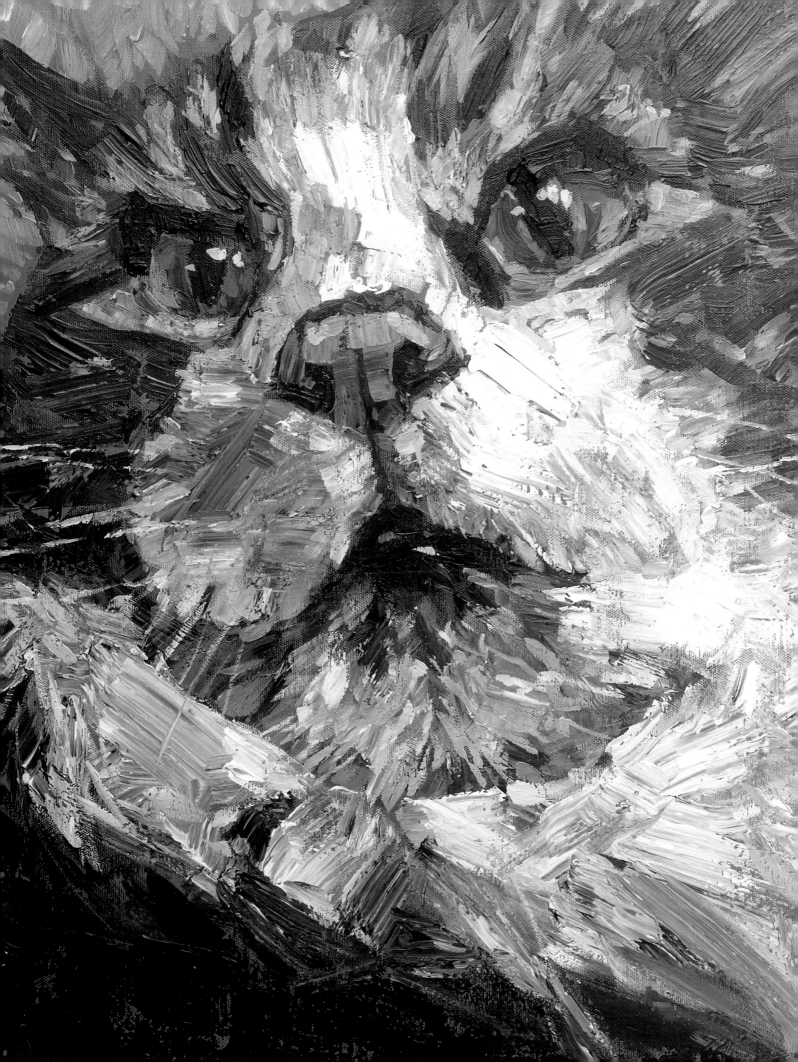

LANDSCAPES

Atmosphere is the key component when painting landscapes. The way light skims across fields, sparkles on water and breaks through lines of trees is magical.

Capturing these effects requires fluid brushstrokes and interesting flecks of colour rather than obsessive detail and fussy edging. Having a feel for the subject can also be useful. Subtle elements can be missed when copying photographs; so take considerations such as the weather into account – was it warm, cold, windy, calm?

Painting landscapes also provides scope for exploring contrasting mark-making possibilities. Spattering, vigorous brushwork or heavy texture can go some way towards replicating the wildness and spontaneity ever-present in nature.

In portraying sunlight in landscape painting, use vibrant warm colours before applying white, as this reproduces the intensity and mimics the heat resonating from the sun.

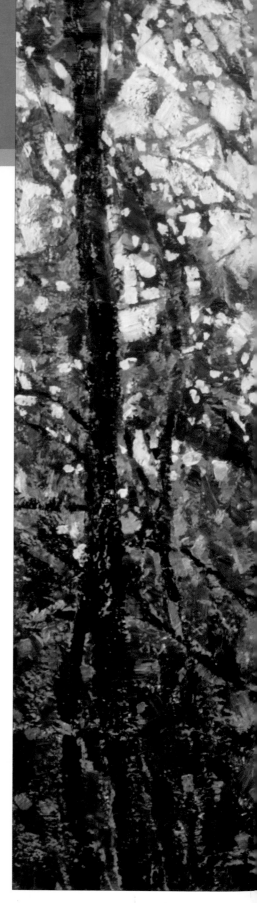

Golden Light

I distinctly remember painting this scene of light shimmering through branches. Having just completed plenty of crowd scenes, the change of pace and of subject was immensely satisfying. I especially enjoyed the almost abstract quality the light gave to the shapes.

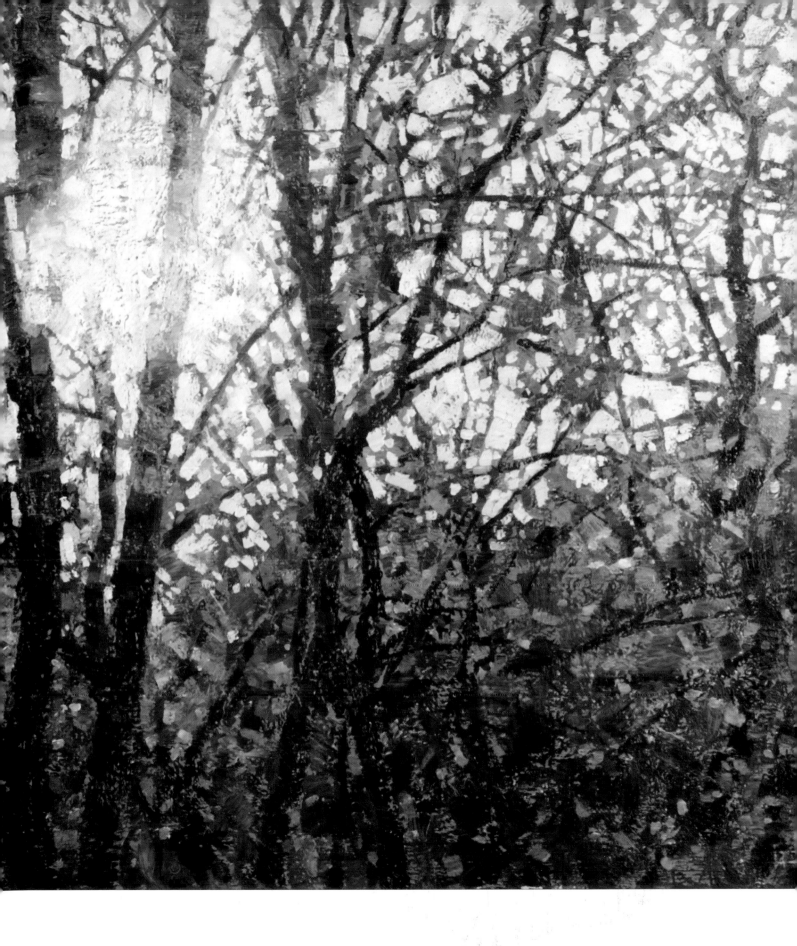

Woodland Light

The way I like to paint subjects that include intense light is to take a mosaic-like approach, allowing the shapes to form naturally by overlaying brushstrokes. The more traditional approach is to apply a light sky and paint lines all over to show branches and leaves. I find these can look tense and contrived: the exact opposite of the impression I want my finished painting to give.

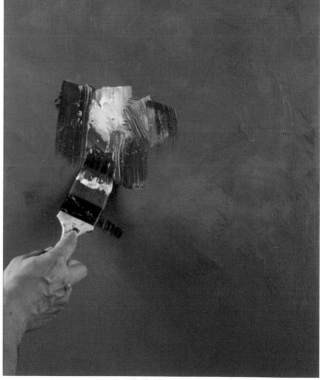

The source photograph for this painting.

You will need

Brushes: 50mm (2in) Sky Flow, 37mm (1½in) Sky Flow, 25mm (1in) short flat

Paint: deep violet, cobalt blue, titanium white, cadmium yellow, lemon yellow, cadmium orange, cadmium red, burnt sienna, sap green, process cyan, phthalo green, process magenta

Canvas: 46 x 61cm (18 x 24in)

Water pot

1 Mix deep violet, cobalt blue and titanium white together on your palette, then use the 50mm (2in) Sky Flow brush to apply the mix to the canvas. Blend the paint on the surface to create a uniform colour and rich texture. Allow to dry thoroughly.

2 Suggest the glow of the sun by applying heavy cadmium yellow and lemon yellow to the left-hand side. This will act as a strong light source and focal point. Pick up cadmium orange and cadmium red and work away from the sun with short, gliding strokes.

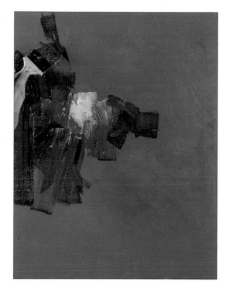

3 Continue working away from, and around, the sun. Introduce deep violet and burnt sienna as you work further away. Vary the angles, lengths and pressure in the strokes of the brush.

Tip

Not cleaning the brush before reloading it means that touches of the colours used previously can appear unexpectedly in your brushstrokes. This will help to tie the finished painting together.

4 Use the edge of the brush with the paint remaining on it to indicate where the main branches of the tree will sit on the upper edge, then load your brush with deep violet and sap green for interesting darks. Apply the paint with strokes that blend with the still-wet red on the canvas to form natural browns.

5 Still using the uncleaned 50mm (2in) Sky Flow, load deep violet, sap green and process cyan. Introduce this to the bottom of the canvas, using varied marks and strokes to build texture.

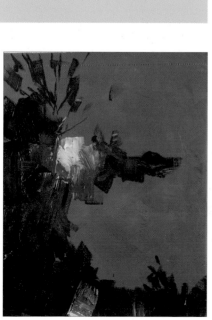

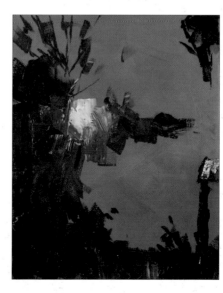

6 Introduce the top and bottom of the trunk of a tree on the right-hand side, using the blade of the brush with deep violet and process cyan.

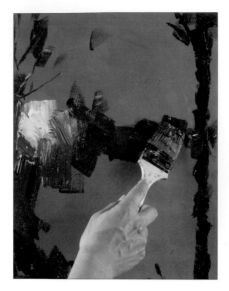

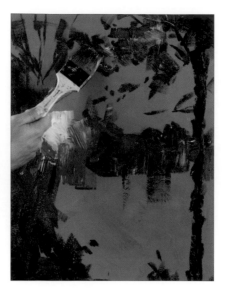

7 Fill the centre of the tree with cadmium red and touches of sap green. This will represent the warm glow of sunlight on the bark.

8 Begin to place the canopy with expressive marks made with the corner of the brush. Use more deep violet and process cyan as you move further from the sun and warmer cadmium red, cadmium yellow and burnt sienna nearer it.

9 Continue to build up the foliage with hot touches of cadmium red and cadmium yellow above the sun. Use bold strokes with the paint remaining on the brush to suggest blurred reflections below the horizon, but do not overwork this area.

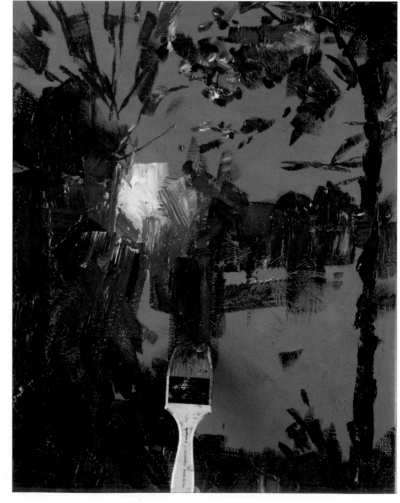

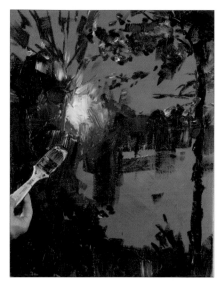 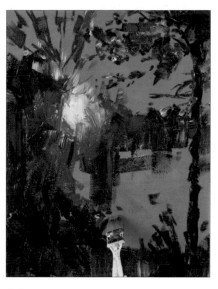 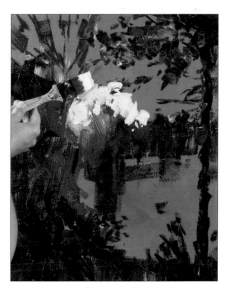

10 Switch to the 37mm (1½in) Sky Flow brush and put in a few smaller strokes of cadmium red and cadmium yellow with the blade of the brush. Apply the paint loosely around the sun in areas that catch the light.

11 Flick in some greens and darks in the same way using sap green and phthalo green. Add these in further from the sun.

12 Heavily load titanium white on your brush and overlay the sun, drawing the wet yellow paint out. Create stark highlights across the horizon with varied brushstrokes.

13 Introduce process cyan touches to the paint on your brush and cut in the small areas of light between the branches further from the sun.

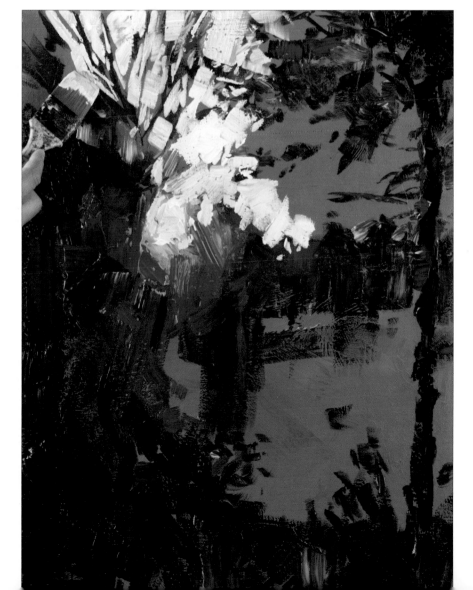

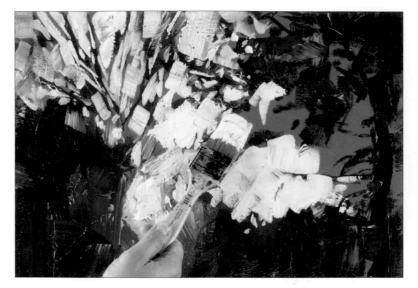

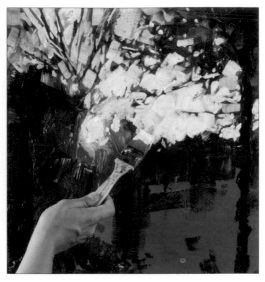

14 As you work still further out, add tiny touches of deep violet to the brush for the most distant areas. Continue to use fairly large, expressive brushstrokes and build up the rest of the sky with the same mixes. Beyond the branches, these squarish brushstrokes should overlay each other.

15 Continue to build up the sky with warmer touches nearer the sun and cooler ones further away. Leave some of the branches suggested earlier intact, but do not be afraid of cutting into them and using them as guidance for where to place your new brushstrokes.

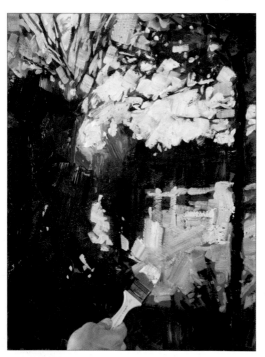

16 When working the water, the mixes must be slightly duller in tone than the light areas they are reflecting. To achieve this, use the same mixes, but do not add pure titanium white. Instead, use a mix of titanium white, process magenta, process cyan and cadmium yellow. Use slightly lighter strokes to suggest the broken surface of the water, and err towards longer, straighter strokes rather than the more chaotic strokes in the sky.

17 Continue building up the reflected light on the surface of the water. Add more process cyan to the mix for the areas furthest from the horizon.

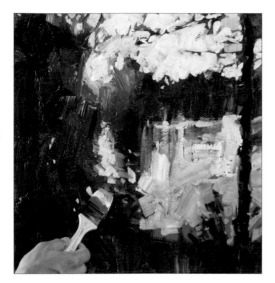

18 Add process magenta to the mix (titanium white, process magenta, process cyan and cadmium yellow) to soften the reflections near the riverbank.

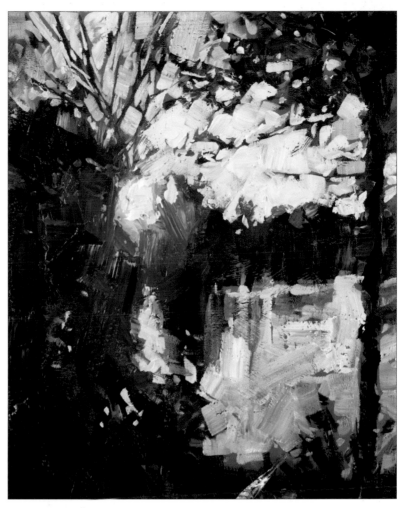

19 Switch to the 25mm (1in) short flat brush and load it with titanium white, cadmium red and cadmium yellow. Still holding the brush near the end of the handle, touch in a few marks to soften any hard lines. Use the paint remaining on the brush to build up the texture near the sun on the trees.

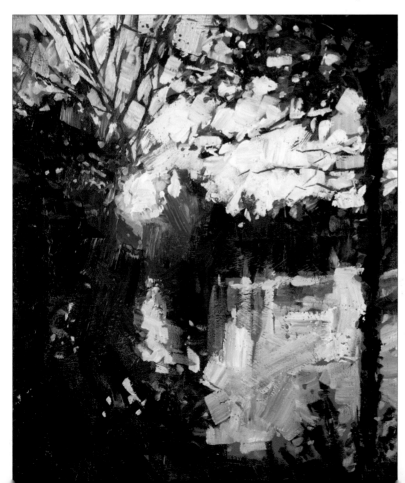

20 Still using the 25mm (1in) short flat, drop in contrasting marks of titanium white, cadmium yellow, lemon yellow and touches of cadmium red on the top right. Use touches of the blade of the brush to suggest branches, or the corner of the brush for sharp points of light.

21 Use the same colours plus cadmium red, burnt sienna and process magenta to add touches to the rest of the top half of the canvas. Keep the touches loose, light and expressive.

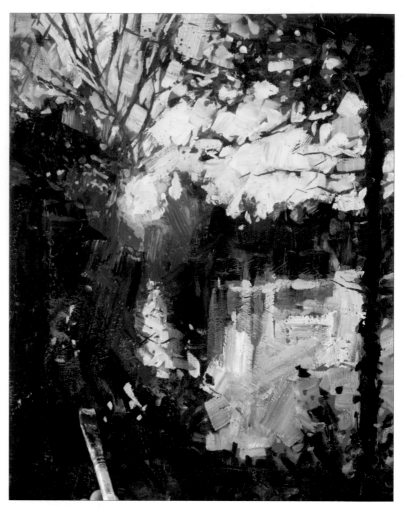

22 Stop picking up cadmium red and cadmium orange; instead loading phthalo green, deep violet and burnt sienna in addition to the titanium white and lemon yellow. Continue building up touches of these colours over the lower half of the painting.

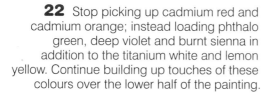

23 Intensify the sun with touches of pure titanium white, then use titanium white and lemon yellow on the area immediately surrounding it. Work outwards from this area, introducing process cyan and cadmium red when you reload the brush. Use more process cyan in the water and more cadmium red on the dark foliage areas.

Opposite:
The finished painting

Rochford Reservoir is fairly unremarkable. It has a few swans, geese and ducks, and dotted around are a couple of benches where you can sit and feed the local wildlife. However, the inclusion of the red glow of strong sunlight, and its reflection in the water, can make even this prosaic scene magical.

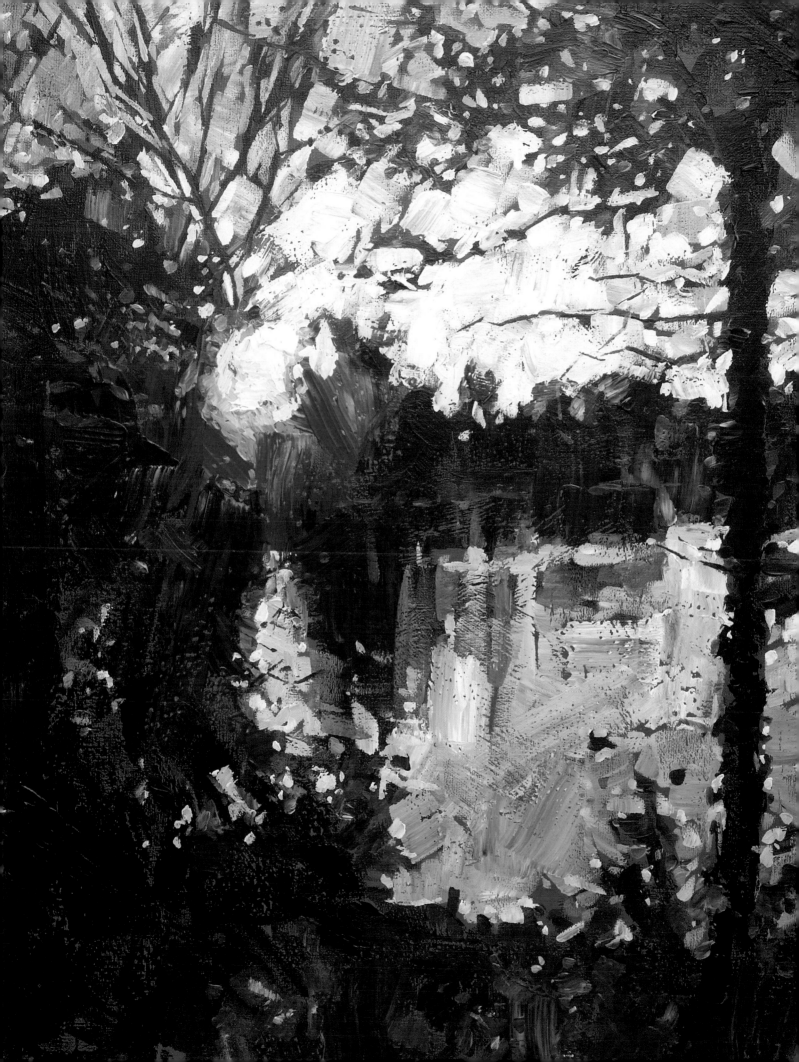

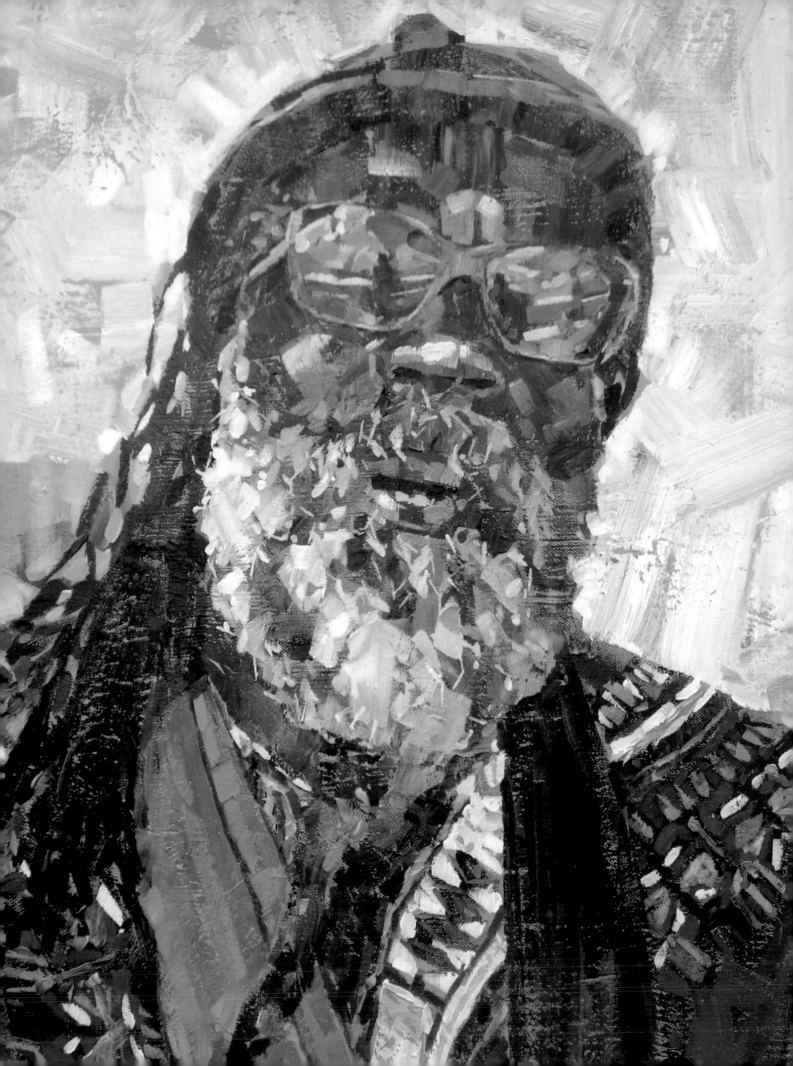

PORTRAITS

For me, the portrait is the ultimate in mastering the technical skills of drawing and painting. Obviously you can paint abstract or expressive portraits which rely less on pinpoint accuracy, but from a purely observational standpoint there is nothing more challenging than achieving a convincing, interesting likeness.

We all have the same facial features, but how they are set marks us out as individuals. Every face you will ever paint will be completely different. Even in twins there may be the odd blemish or wrinkle that sets them apart from the other.

Tackling a portrait requires judging tiny measurements and angles correctly, or the entire likeness can be lost. The key is to establish the basic proportions first, such as the size and position of the eye sockets, nose and mouth in relation to one another. Once these are established, you can move on to consider the smaller details in the eyes, eyelashes, wrinkles etc. that help to evoke an specific individual. Building on a solid foundation will be more fruitful and lead to less frustration in the long run.

Try adding interesting backdrops to the portraits you paint, or ask your sitter to wear something with bright colours to energise the skin tones.

Opposite:
Tropical Taste

This painting is based on a photograph from one of my student's travels to the Caribbean. To some extent the figure is disguised by the sunglasses, beard and hat. These should be seen as valuable props in framing the portrait and a reflection of his personality.

The model is full of life and colour. I did not want to simply replicate the photograph completely, so the brush marks are kept quite loose and the small brushwork kept to a minimum.

Hard Life

Painting a variety of nationalities is very interesting and useful, as skin colour, hair and facial features can be subtly, or even dramatically, different. This project will help you to reinterpret and appreciate how you might mix colours for creating warmth, particularly in the skin tones.

 Lots of wrinkles and lines are not always necessary to show age or character. Finding the essential, distinctive ones is more important. You can convey a lot through the way the brushstrokes are applied.

The source photograph for this painting.
© L. Meall.

You will need

Brushes: 50mm (2in) Sky Flow, 25mm (1in) short flat
Paint: phthalo green, coeruleum blue, titanium white, burnt sienna, deep violet, cadmium red, process magenta, sap green, cadmium orange, yellow ochre, cadmium yellow, lemon yellow, process cyan, cobalt blue
Canvas: 46 x 61cm (18 x 24in)
Water pot

1 Mix phthalo green, coeruleum blue and titanium white together with the 50mm (2in) Sky Flow brush, then use it to lay a smooth ground on to the canvas.

2 Clean and dry your brush then load it with burnt sienna, deep violet, cadmium red and a little process magenta. Lay a few bold strokes in a vertical line down the centre of the canvas.

3 Build up the structure on the left with bold downwards strokes using the whole length of the bristles. Pick up some sap green and phthalo green along with the other colours and apply the paint on the left hand side of the face for shading.

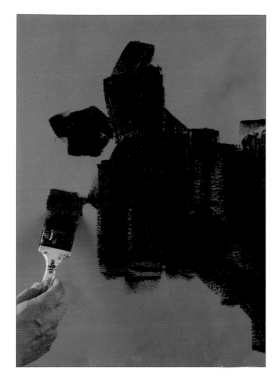

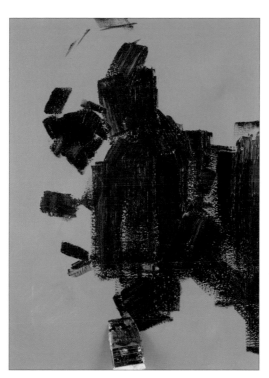

4 Load warmer colours: cadmium red, burnt sienna, deep violet and touches of cadmium orange. Build up the cheekbone, eye socket and shadow of the nose with more controlled strokes that utilise only the front third of the bristles.

5 Suggest the mouth using the paint remaining on the brush and two light touches of the brush. Use the reference photograph to add a few guideline marks for the shape of the forehead, ear and jaw, using deep violet, phthalo green and burnt sienna.

6 Use burnt sienna, cadmium red, process magenta and cadmium orange to drop in warm areas to pick out the ear.

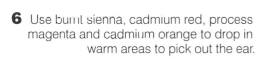

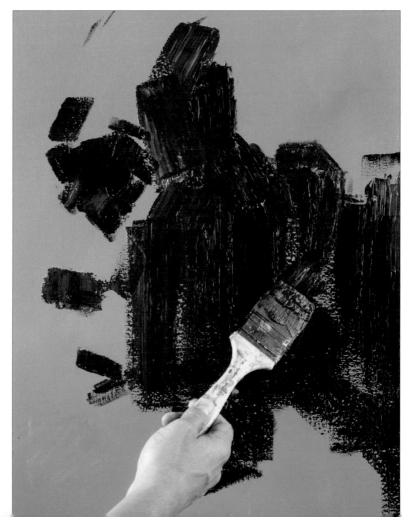

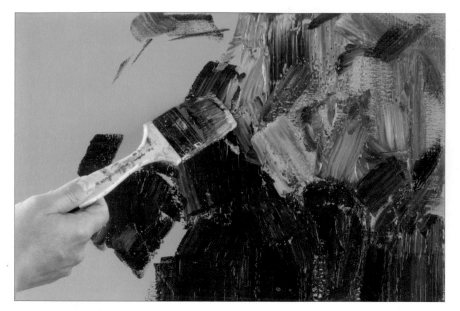

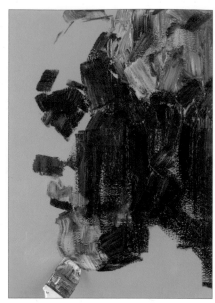

7 Do not clean the brush. Begin to lay in the hair with lighter-toned colours: load yellow ochre, coeruleum blue and sap green. The majority of the brushstrokes you apply should create texture, so use many curt, opposing brushstrokes. Pick up a little deep violet for the back of the hair and areas in shadow.

8 Use the same colours with shorter brushstrokes for the man's stubble. Add cadmium yellow and suggest reflected light on the bottom of the beard.

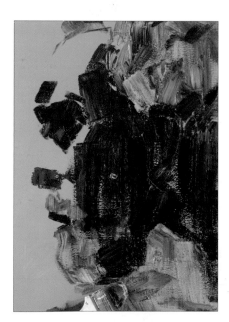

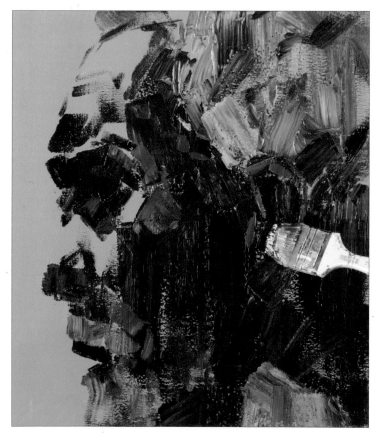

9 Block in the shirt with the reflected light colours (yellow ochre, coeruleum blue, sap green and cadmium yellow).

10 Pick up the warm colours (cadmium red, burnt sienna, cadmium orange and deep violet) and suggest furrows, veins, wrinkles and other texture with short, flicking motions amongst the stubble, eye, forehead, cheek and ear.

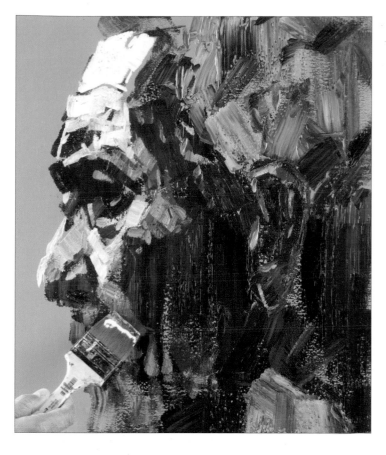

11 Clean and dry your brush. Load it with plenty of titanium white along with lemon yellow, burnt sienna, process cyan and process magenta. Leaving a few small patches of the blue basecoat showing through, use short strokes and touches of the brush blade to add in the sheen of reflected light on the skin. To achieve a natural effect, use short, broken strokes and occasionally introduce tiny touches of cadmium red and cadmium orange as you reload the brush.

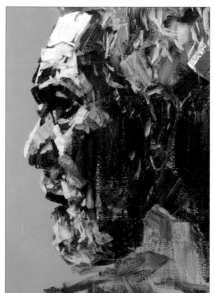

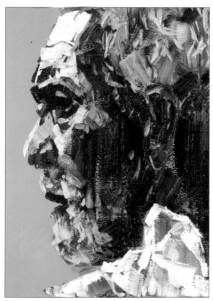

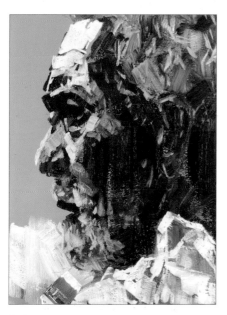

12 Clean and dry the brush, then load it with plenty of titanium white along with burnt sienna, yellow ochre and sap green and use it to paint the stubble and hair. Resist the temptation to simply stipple tiny marks: vary the marks with slightly longer, more adventurous strokes.

13 Develop the shirt with strong highlights of titanium white with additional touches of lemon yellow and process cyan. Add some cadmium yellow and sap green to paint in the midtones.

14 Clean and dry your brush, then load titanium white, deep violet and cobalt blue. Use the whole width of the brush to overlay the background at the bottom. Do not follow the line of the jaw: bring strokes in from various angles to leave a few touches of the base colour showing through.

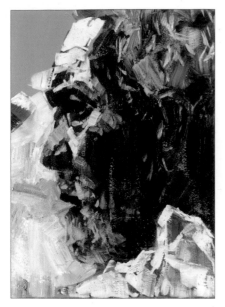 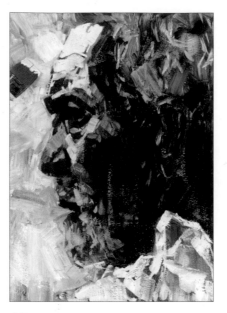 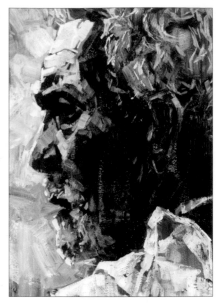

15 Load additional sap green and cadmium yellow as you work upwards into the central background. Add more titanium white as you work past the nose.

16 Complete the upper background with titanium white, cadmium red, process magenta and cobalt blue at the very top.

17 Switch to the 25mm (1in) short flat brush and load it with titanium white and lemon yellow for the ultimate highlights. Punctuate the painting with small, strong, broken strokes, concentrating on the areas in direct sunlight such as the forehead, shirt, stubble and hair.

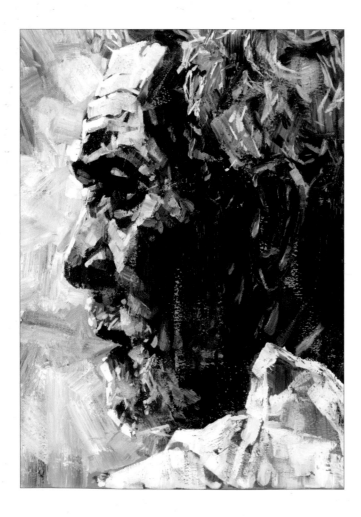

18 Load the 25mm (1in) short flat with titanium white, burnt sienna, yellow ochre and cadmium red. Vary the hue with deep violet and cadmium orange, and use light gliding strokes to add shape to the skin areas by making subtle connections between the cruder brushstrokes made earlier.

Opposite:
The finished painting

This man has an amazing face, with all of life's experience written on it. The photograph is from a series of portraits a friend took on her travels through India, and it is the one that I felt had most character. Profiles can be a bit tricky, but in compositional terms a figure looking away can be more intriguing than one looking directly at you.

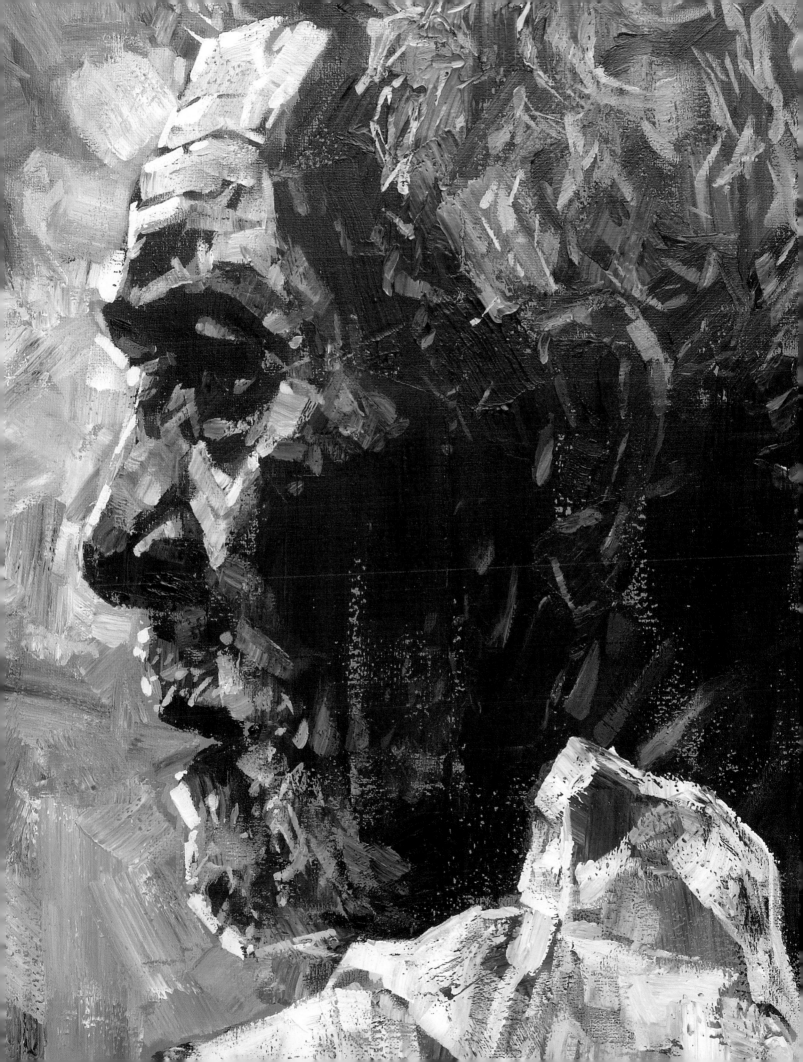

CROWDS

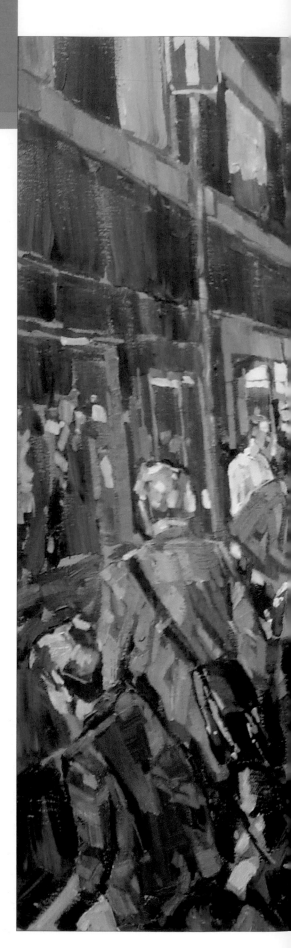

Crowd scenes are my favourite subject. I love the hustle and bustle of the scene, and replicating all the elements can be a challenge. Achieving a balance between portraying the bustle and confusion of the crowd and successfully creating a pleasing image is very rewarding.

Each character in a crowd has a personality and creates a pocket of interest. Flecks of colour from shirts or umbrellas can be very effective to develop interest in areas of dark shadows or muted tints. However, it is vital to edit these features to provide the absolute key elements, otherwise you will get bogged down with unnecessary details.

Brick Lane Sunday

The eye is drawn to faces, which can lead the viewer's eye away from more important focal points of your composition. Because of this, it can be convenient in crowd scenes if the figures are looking away or have their backs turned. Failing this, the use of heavy shadows or blurring facial features guarantees nondescript portraits of individuals, resulting in a more fluid overall composition. Individuals are shown using posture and shapes.

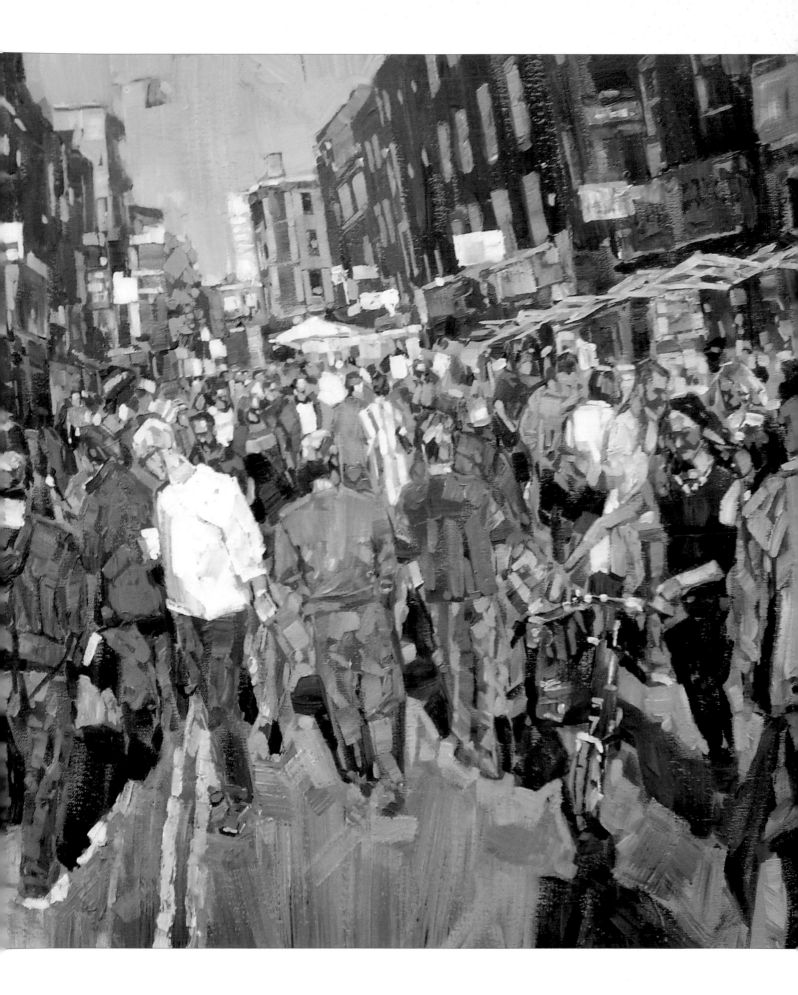

Brick Lane Sun

Brick Lane seemed to be my second home for a while, and each visit on market day provided another varied scene to paint.

Potentially, I could have developed more detail in a crowd scene like this, but anything you add in refinement you take away in freshness. The exuberance of the initial marks are key to maintaining a level of spontaneity in the finished painting.

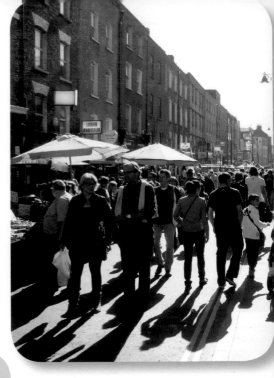

The source photograph for this painting.

You will need

Brushes: 50mm (2in) Sky Flow, 25mm (1in) short flat, 37mm (1½in) Sky Flow, 7mm (¼in) long flat

Paint: coeruleum blue, titanium white, yellow ochre, burnt sienna, sap green, process cyan, deep violet, lemon yellow, cadmium yellow, yellow ochre, cadmium red, cadmium orange, phthalo green, process magenta

Canvas: 46 x 61cm (18 x 24in)

Water pot

1 Lay in a smooth, even ground of coeruleum blue and titanium white using the 50mm (2in) Sky Flow brush.

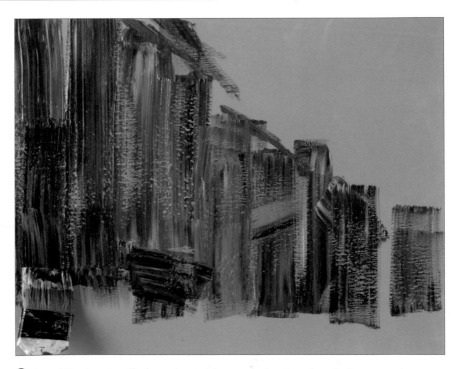

2 Load the brush with coeruleum blue, yellow ochre, burnt sienna and sap green. Use strong vertical strokes to establish the main terrace of buildings. Vary the strokes with diagonal marks made with less pressure, and deepen the tone by adding deep violet for variety.

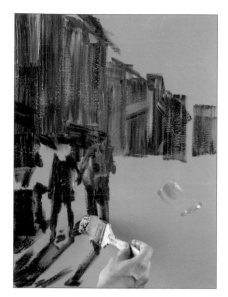

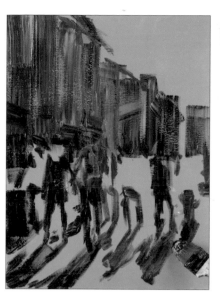

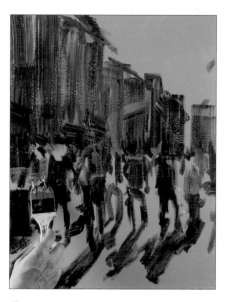

3 Establish the dark areas and shadows of the two foremost figures on the left-hand side using a dark mix of process cyan, sap green and deep violet. Add burnt sienna and coeruleum blue to create interesting variations in the shadow areas.

4 Establish the other foreground figures, adding more coeruleum blue when reloading the brush for lighter shadows.

5 Without cleaning your brush, load burnt sienna and yellow ochre. Use this mix to touch in midtones on the foreground figures, then add more coeruleum blue to hint at figures behind them in the midground.

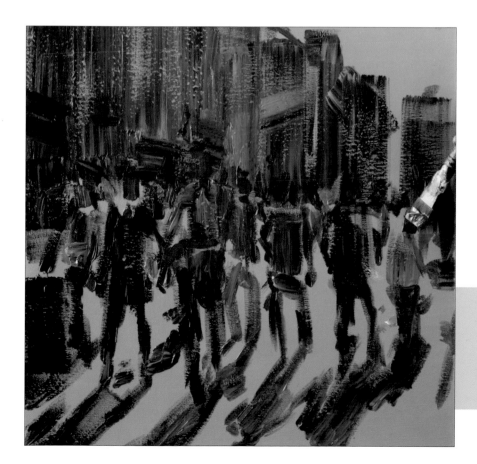

6 Do not clean the 50mm (2in) Sky Flow brush, but put it to one side. Load the 25mm (1in) short flat brush with cadmium red, cadmium yellow and burnt sienna. Use the corner of the brush with these rich colours to make small but powerful marks to establish areas of skin.

Tip
The warm colours used on the skin contrast greatly with the cool blue of the background.

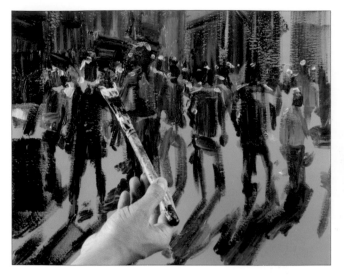

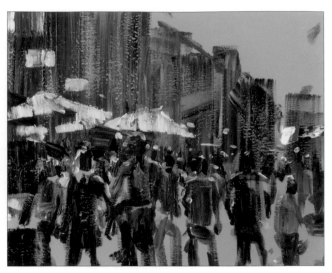

7 Load lemon yellow and cadmium yellow and use curt, controlled strokes to establish the lightest areas on the figures. Use the corner and blade of the 25mm (1in) short flat brush to make these marks.

8 Add a few touches of the same mix to the background, then load your brush very heavily with cadmium yellow and lemon yellow. With very light strokes, so that the paint transfers without smearing the wet layers underneath it, establish the parasols and signage on the terrace.

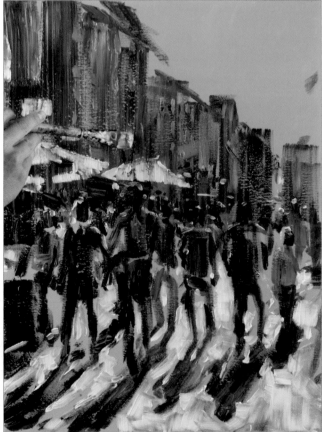

9 Establish the bright areas on the pavement with the same colours. As the area is dry, you need less paint. Use short strokes in amongst the shadows, overlaying the blue but leaving small areas of the basecoat showing.

10 Load cadmium red and cadmium orange to punctuate the background with signage, then scrape off the excess paint from the brush on your palette. Reload coeruleum blue and yellow ochre on the brush and touch in windows on the terraced building.

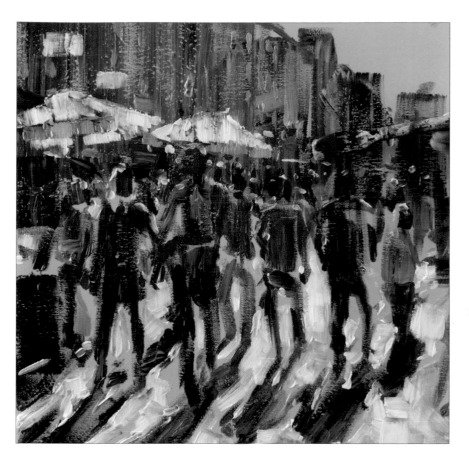

11 Load cadmium yellow and yellow ochre, and lay in subtle variation on the parasols, then pick up some phthalo green and lemon yellow to add in some pockets of colour across the foreground.

12 Using the corner of a clean 25mm (1in) short flat brush, add in touches of process magenta.

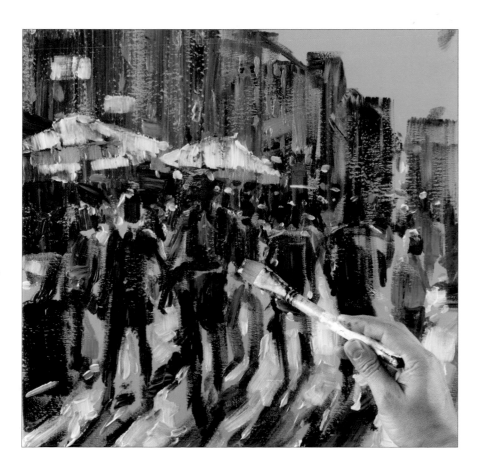

21 Load titanium white, cadmium yellow and cadmium red on the 7mm (¼in) long flat and pick out highlights on the skin areas of the crowd. A few small strokes – one for the forehead and one for the nose – will suffice to suggest a face without becoming fussy. Add burnt sienna and lemon yellow when reloading, for variety.

22 Load yellow ochre, burnt sienna, sap green and cadmium yellow on the 25mm (1in) short flat brush. Use this to pick out some lighter clothing in the crowd. Do the same with the blue clothing, using process cyan, titanium white and cadmium yellow, adding deep violet for shaded parts.

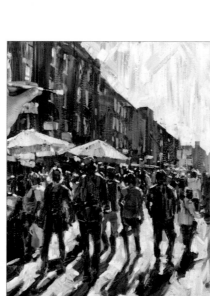

Tip

Keep the touches in these final stages small, light and subtle. They should add texture and highlight only small areas.

23 Clean and dry the brush, then add in the strongest highlights using lots of titanium white and a little lemon yellow. Concentrate on the parasols and the road in the foreground.

24 Use the same colours to highlight the figures with the 7mm (¼in) long flat brush. Add process cyan to the mix and pick out reflections in the windows. Make any final tweaks using the mixes on your palette.

Opposite:

The finished painting

Using yellow in the road and fragments in the sky creates the impression of early morning light and helps to strengthen the contrast between the warm light and cool shadows. Details in the buildings are kept simple to draw the eye to the flecks of colour in the crowd.

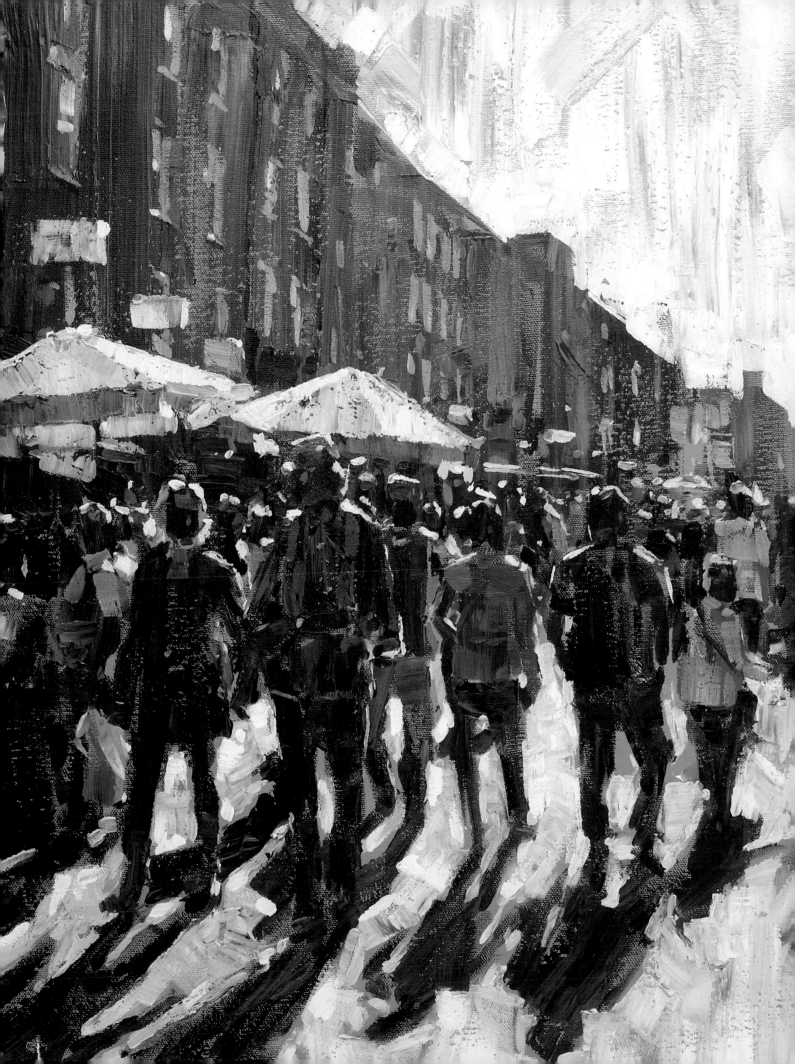

BUILDINGS

Buildings have multiple straight lines which create hard edges. These hard edges grate against the eyes, so when painting architectural subjects, try softening or diffusing them. Aim to suggest the lines of the building without allowing them to become too harsh or precise.

Similarly, try not to paint every window and door in vivid detail – overworking these details can be distracting and will draw attention away from both the overall image and the focal point on which you want the viewer to focus.

Connecting shapes using shadows is a sure-fire way of integrating figures, cars and buildings all together. Finally, avoid using rulers at all costs. There is more personality in lines drawn freehand, even if they are a bit shaky.

Opposite:

Lloyds

I always think this painting has the suggestion of science fiction about it. The stark, modern architecture; the reflective glass and industrial tubing; even the figures in their suits looks like they are overseeing a mission launch of the 'Gherkin' building at the back. The colours are deliberately kept cool to reflect the corporate nature of the scene, with minimal warm shades punctuating the figures.

Rush Hour

There are lots of challenges in this complex street scene filled with cars and architecture. The solution is breaking the elements down into simple, manageable shapes.

 Simplicity is paramount. Think of the buildings as angled boxes: long, short and tall; and the cars as smaller boxes with slight curves and sharper angles. Pay careful attention to the perspective and the lighting, as the shadows mask out a lot of unnecessary detail and are helpful with connecting the shapes.

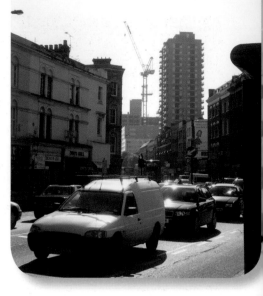

The source photograph for this painting.

You will need

Brushes: 50mm (2in) Sky Flow, 25mm (1in) short flat, 37mm (1½in) Sky Flow, 7mm (¼in) long flat

Paint: process magenta, coeruleum blue, burnt sienna, sap green cobalt blue, deep violet, process cyan, cadmium red, cadmium yellow, titanium white, lemon yellow, yellow ochre

Canvas: 46 x 61cm (18 x 24in)

Water pot

1 Lay in a smooth, even ground of process magenta with the 50mm (2in) Sky Flow brush.

2 Use the blade of the 25mm (1in) short flat brush and coeruleum blue to lay in minimal outlines of the main structures. Refer to the photograph throughout, but resist the temptation to over-clutter. Add in only the most prominent areas as shown.

4 Establish the darks on the right-hand building using the 50mm (2in) Sky Flow brush, loading it with burnt sienna, sap green, coeruleum blue, cobalt blue and a touch of deep violet. Lay on the paint generously and fluidly in as few strokes as possible.

Tip
Using fewer strokes ensures that the colours on the brush do not get mixed together and dirty, so areas of pure, clean colour show through as you draw the brush.

3 Add in a few additional details, but concentrate on vital areas, such as the two facing terraces, the foreground van, midground traffic and the skyscraper and crane in the background.

Tip
These marks will not show in the final stages, so regard them as practice strokes and ensure that the main areas are in proportion to one another.

5 Link the dark shadows of the building with the car shadows, adding process cyan as you advance to the foreground. For lighter shades (such as the car doors catching reflected light) use more cobalt blue and sap green. You may need to use shorter strokes, but keep the application light.

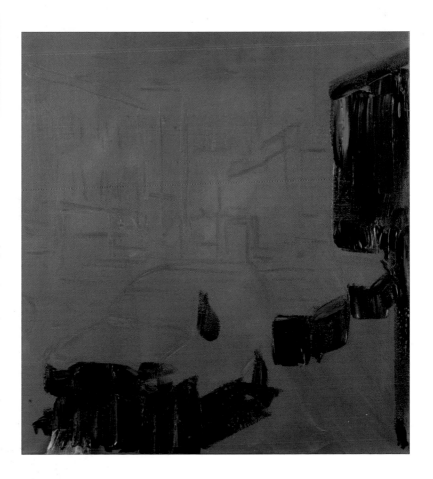

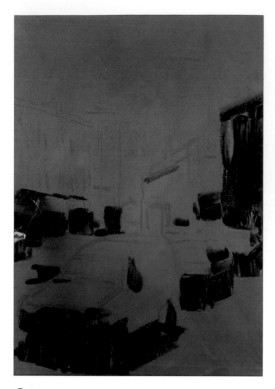

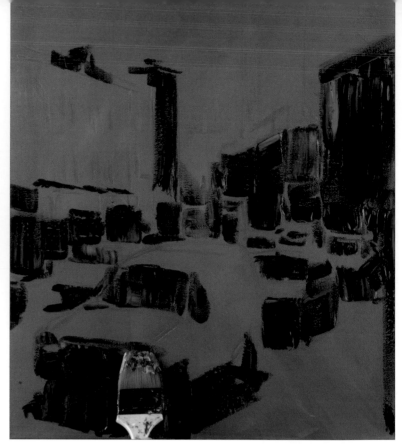

6 Paint in the other strong foreground shadows using the same colours (burnt sienna, sap green, coeruleum blue, cobalt blue and a touch of deep violet).

7 Reload your brush with more cobalt blue, burnt sienna, sap green and coeruleum blue; with less deep violet and no process cyan. Paint in the shadows in the midground, then use the same mix for the windscreens. Aim for variety in the colours each brushstroke creates by continually reloading with slightly different proportions of the colours.

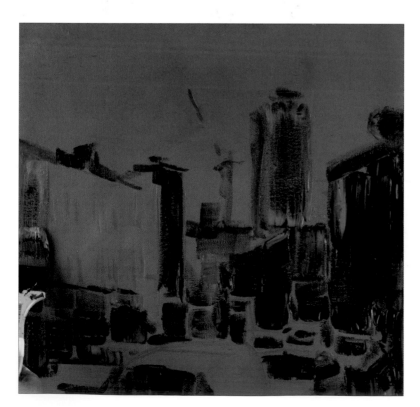

8 Using a lighter touch, so the marks are more granular, use sap green and coeruleum blue to establish the shapes of the background buildings and the shop fronts on the left-hand side.

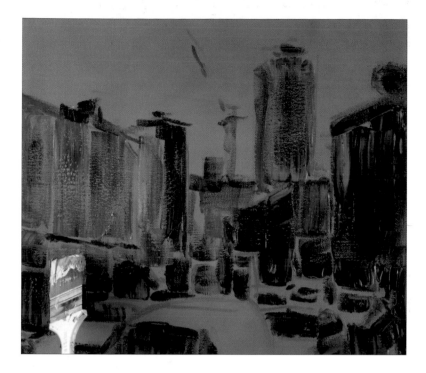

9 Load yellow ochre, sap green and coeruleum blue with a touch of burnt sienna, and establish strong midtones on the foreground. The yellow ochre is opaque, so it gives strength to these important foreground elements.

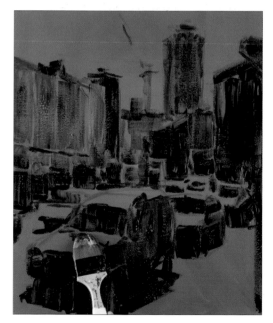

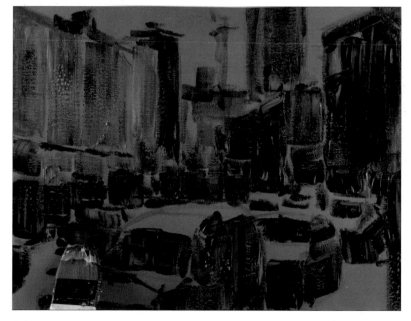

10 Load burnt sienna, yellow ochre and deep violet to your brush. Paint the shaded side of the van, then add subtle touches to the background skyscraper with the paint remaining on the bristles. Pick up a little sap green and blend a few strokes up from the shadow areas across the painting.

11 Integrate cadmium red when reloading and introduce hot elements in the bus near the centre of the midground and the truck on the lower left.

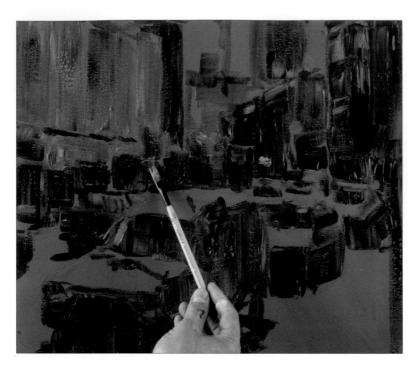

12 Change to the 37mm (1½in) Sky Flow brush. Pick up cadmium red and cadmium yellow and add hot spots across the foreground. These will represent the brightest points of light and reflections. Switch to the 7mm (¼in) long flat, holding it near the back of the handle for particularly small touches, then load it with pure coeruleum blue and create eye-catching cool points to contrast with the hot spots.

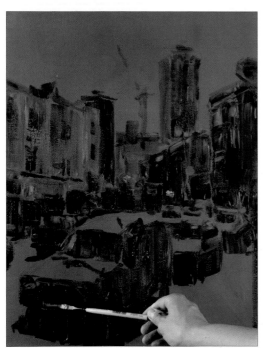

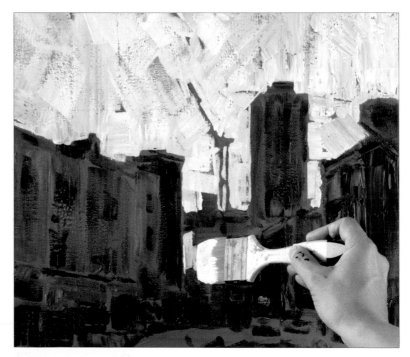

13 Still holding the 7mm (¼in) long flat brush near the back of the handle, add in a few hints of windows in the foreground with deep violet and process cyan. Use the same mix to add shaping to the traffic in the foreground, such as the van's numberplate. Resist the urge to be fussy: stay expressive and loose.

14 With the darks and initial midtones established, load a clean 50mm (2in) Sky Flow brush with titanium white and a little lemon yellow, process magenta and process cyan. Apply strong, assertive brushstrokes to the sky. Use the blade of the brush for hard-to-reach areas; and pay particular attention to suggesting the crane through negative painting.

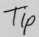

Vary the brushstrokes used in the sky. Vertical strokes echo the brushstrokes used on the building, while contrasting diagonals and horizontals create contrast and interest.

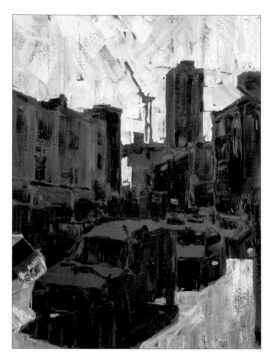

15 Add sap green, burnt sienna and cadmium yellow to the sky colours left on the brush. Establish the tarmac area, using the corner of the brush to touch in points of light, and drawing the brush in narrow strokes to establish the shape of the road.

16 Reload the brush with all the colours used for the tarmac (plenty of titanium white, with small amounts of lemon yellow, process magenta, process cyan, sap green, burnt sienna and cadmium yellow) and use the blade of the brush to establish the main areas of the van in the foreground.

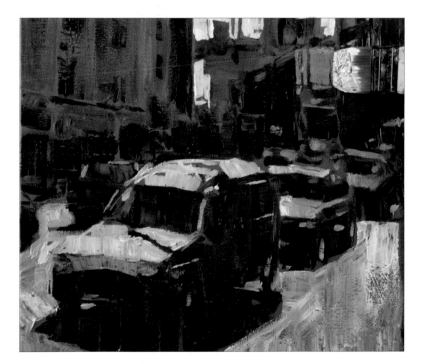

Tip
Using hints of the same colour in different parts of the painting, such as the blue-green mix in the midground and foreground here, helps to relate different parts of the painting to one another.

17 Add more process cyan and pick out the car immediately behind the van. Use the same mix on the headlights and hubcaps of the vehicles in the traffic, then add subtle highlights across the rest of the foreground and midground.

18 Load titanium white, sap green and process cyan on to a 50mm (2in) Sky Flow brush and suggest a few highlights on the background buildings. Add more burnt sienna and cadmium yellow and use the very tip of the brush to pick out the main colour of the building on the end of the left-hand terrace.

19 Paint the other buildings in the terrace in the same way, adding more cadmium yellow to warm the colour and process cyan for the leftmost building. Keep the angle of your brushstrokes fairly even to emphasise the structural nature of the buildings and follow the line of recession.

20 Load a clean 50mm (2in) Sky Flow brush with titanium white and a little burnt sienna, sap green and deep violet. Use this with the blade and corner of the brush to suggest the structures of the background buildings. Vary the mix with sap green.

21 Vary the mix with burnt sienna and add accenting touches to the foreground van. Load a touch of cadmium yellow to the paint remaining on the brush and detail the signage on the terraces.

22 Load a clean 37mm (1½in) Sky Flow brush with phthalo green, deep violet, burnt sienna and process cyan to add strong dark marks. Pick out small touches in areas such as the traffic lights in the midground and the edges of the architecture and windscreens to sharpen the edges and help to bring clarity to the image.

23 Take a step back and make any adjustments you think will strengthen the composition. The eye is led into the centre, so use a 7mm (¼in) long flat brush to touch in some subtle detailing with the colours used in step 22. These strengthen the focal point and make the midground more coherent.

24 Mix titanium white with lemon yellow and drop in the strongest highlights in the foreground using the 25mm (1in) short flat. Vary the length and angle of the marks and use the corner of the brush to pick out the centre of the hot spots.

25 Add process cyan and yellow ochre when reloading, and bring in more muted highlighting in the midground and on the terraced buildings. Use the paint remaining on the brush to edge the signs and window ledges.

26 Load titanium white and process cyan on to a clean 25mm (1in) short flat and use small touches to accentuate the sky near the edges of the buildings. You can cut into areas like the balconies of the skyscraper to sharpen them, but resist the urge to over-tidy, as this will look fussy and kill the spontaneity and impact of the painting.

27 Make any final adjustments. I have added cadmium red with a little cadmium yellow added to the traffic lights and tail light of the red car on the lower left, then extended the front wing of the van using plenty of titanium white, with small amounts of process magenta, process cyan, sap green, burnt sienna and cadmium yellow.

Opposite:
The finished painting
As unglamorous as this scene is, it does show a certain everyday quality of city streets. The traffic, cranes, buildings both old and new; all make a change from seeing predictable tourist haunts. Other than the touches of hot pink ground that filter through, the colours are relatively sombre, to maintain a grittiness to the painting.

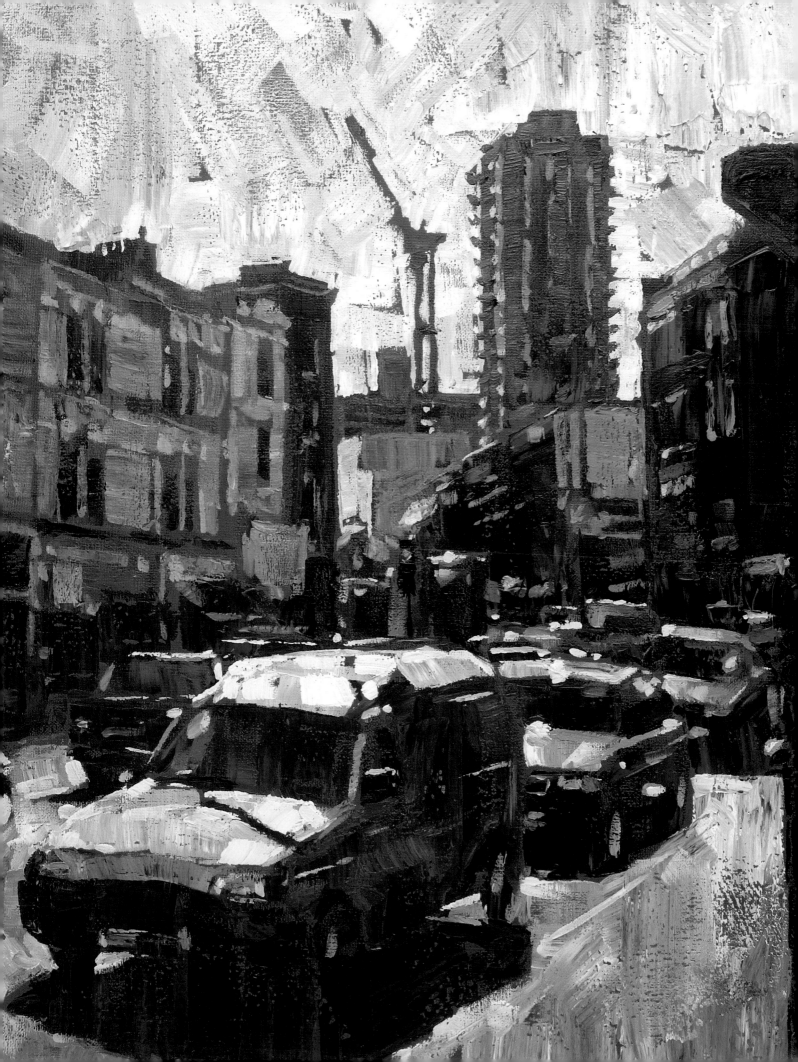

ABSTRACTS

I have found there is a natural evolution in most artists' painting. They start with Realism and move on to Impressionism, then on to Expressionism and into abstract works. When you move into abstract painting, your creative work becomes an opportunity to express emotion rather than anything representational.

Discovering pure abstract forms begins with observing interesting shapes in everyday scenes or objects. Choosing unconventional scenes to paint can open doors to finding new and exciting ways to paint. Camera effects, extreme close-ups or editing information to a minimum can start you on the journey to abstraction. After a while you may start using just your imagination in expressing your art.

Light Cornucopia

Anything goes in abstracts, but the skill lies in keeping your identity as an artist. The application and direct mixing of paint is still very much my trademark in this example, but the scene is liberated from anything too formally representative. There are still large flowing brush marks against smaller ones, but colour interaction plays a more pivotal role than in my more representational pieces.

Light Tracks

This scene has both a recognisable aspect to it and a strong abstract quality. Night scenes are unusual to paint, but it is always worth looking at scenes in different lighting or weather conditions. Taking this idea further, you might like to try viewing scenes or elements of scenes underwater. Looking through rippling water can produce interesting abstractions.

The interaction of the lines and shapes with the strong light, all executed with minimum fuss, plays a major part in creating this painting's impact.

The source photograph for this painting.

You will need

Brushes: 50mm (2in) Sky Flow, 25mm (1in) short flat, 37mm (1½in) Sky Flow, 7mm (¼in) long flat
Paint: phthalo green, deep violet, titanium white, sap green, yellow ochre, burnt sienna, coeruleum blue, cadmium yellow, process cyan, cadmium orange, lemon yellow, cadmium red
Canvas: 46 x 61cm (18 x 24in)
Water pot

Tip

Different combinations of colours for the basecoat applied in step 1 will give very different effects to the finished painting. Try experimenting with a different background once you have worked through this project.

1 Lay down a ground of phthalo green and deep violet softened with titanium white. Aim to produce a textured, variegated basecoat by applying loose, random strokes with the 50mm (2in) Sky Flow brush.

2 Clean and dry your brush, then load it with sap green, yellow ochre, burnt sienna, coeruleum blue and a little titanium white. Apply a few horizontal strokes across the bottom, then reload with more coeruleum blue and apply a few looser marks above.

3 Scrape the paint off the brush on your palette so that only a little remains, then load it with burnt sienna, cadmium yellow and yellow ochre. Introduce some warm areas, loosely radiating out from the green area at the bottom.

4 Reload the brush with the same colours plus sap green. Draw long, light strokes in from the edges, leaving a 'v' at the top nearly clear.

5 Heavily load a clean 50mm (2in) Sky Flow brush with deep violet, process cyan and phthalo green. Block in a dark area in and around the central 'v' shape, aiming to produce a heavy, textural effect on the canvas with your brushstrokes.

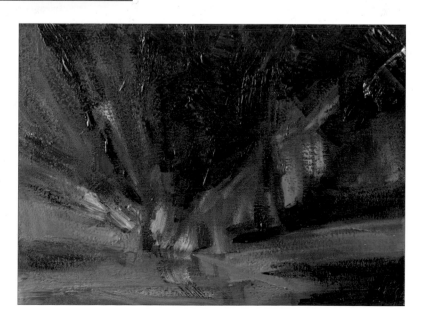

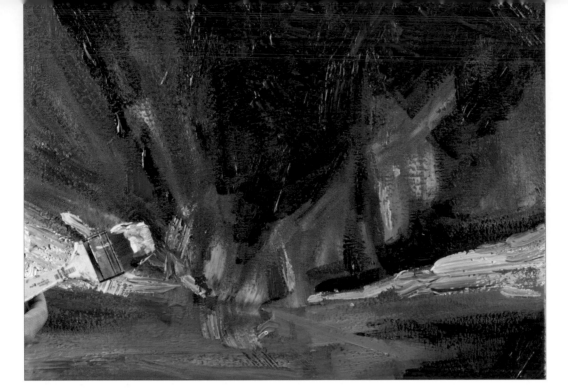

6 Clean and dry the brush, then load it heavily with titanium white and process cyan. Hold the brush near the end of the bristles to ensure your brushstrokes are uncontrived. Use short strokes to create two strong, cool areas that lead into the centre.

7 Clean the brush thoroughly and load it with cadmium yellow, burnt sienna, cadmium orange and lemon yellow. Create a warm, broken area radiating out from the central focal point to the centre of the left-hand side.

8 While the paint is wet, use a clean 37mm (1½in) Sky Flow brush loaded with sap green, cadmium yellow and burnt sienna to blend the colour outwards.

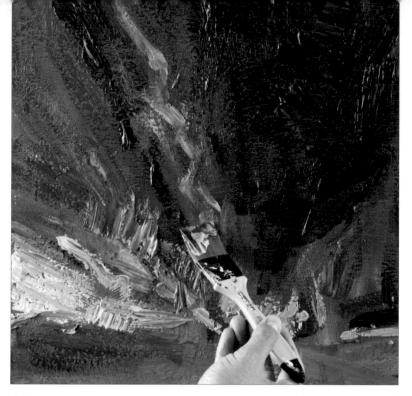

9 Reload the brush with the same colours, and create light touches in a loose, broken zig-zag pattern radiating up to the top left from the focal point.

10 Blend the colours into the background slightly with smooth, light touches of the 27mm (1½in) Sky Flow brush.

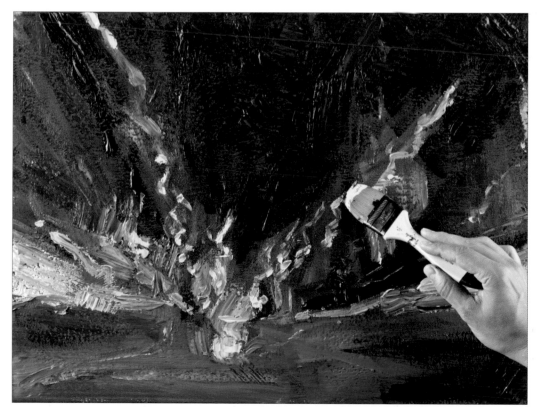

11 Build up more warm areas radiating out from the focal point with the same colours. Use the two brushes in concert; applying the paint with one 37mm (1½in) Sky Flow and blending it in with the other.

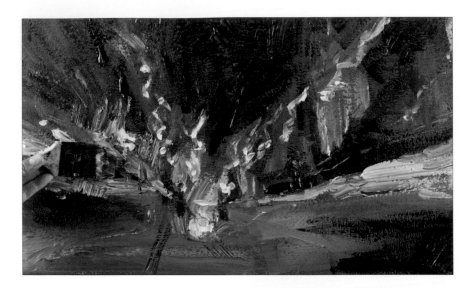

12 Add a few hot spots in amongst the radiating warm areas using cadmium red and burnt sienna around the focal point. Apply the colour sparingly with the corner of the 50mm (2in) Sky Flow brush.

13 Load a clean 37mm (1½in) Sky Flow brush with titanium white and a little cadmium yellow. Leaving sections of the blue ground visible, apply the paint inside the cool blue to create a vibrant glow.

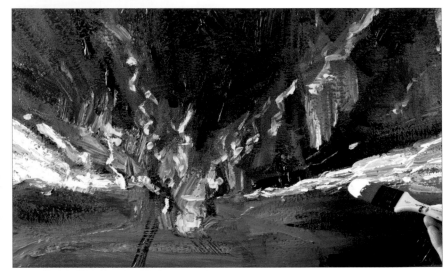

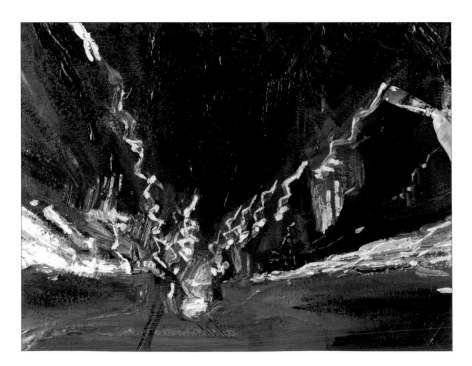

14 Switch to a 25mm (1in) flat and load it with titanium white, a little lemon yellow and a little cadmium yellow. Use the blade of the brush to create lines inside the warm yellow and orange areas. These suggest streaks of light, which invest the painting with dynamism and movement. For dimmer areas, add some cadmium orange.

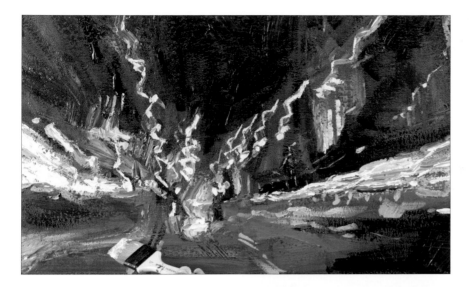

15 Load a 37mm (1½in) Sky Flow brush with titanium white, burnt sienna and coeruleum blue. Apply some light, near-horizontal strokes to the foreground. These small marks give a sense of balance and grounding by adding interest away from the radiating streaks of cool and warm light.

16 Load burnt sienna, sap green, phthalo green and deep violet to the brush. Use this dark combination to cut in near the brightest points of colour, in order to create the maximum contrast in tone at these points.

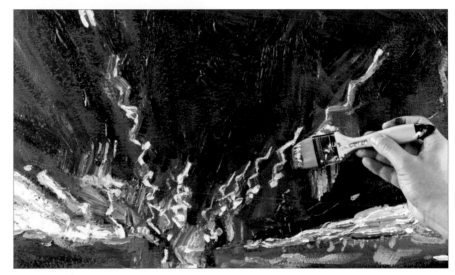

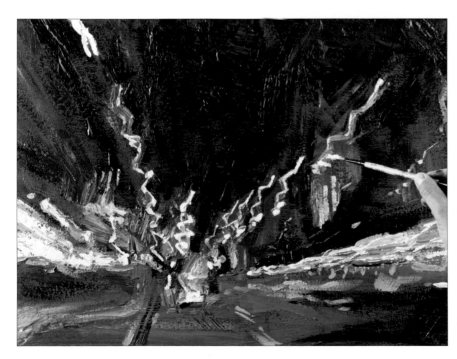

17 Use the 7mm (¼in) long flat brush to add extremely bright highlights of titanium white with a little lemon yellow to the brightest points of the streaks of light.

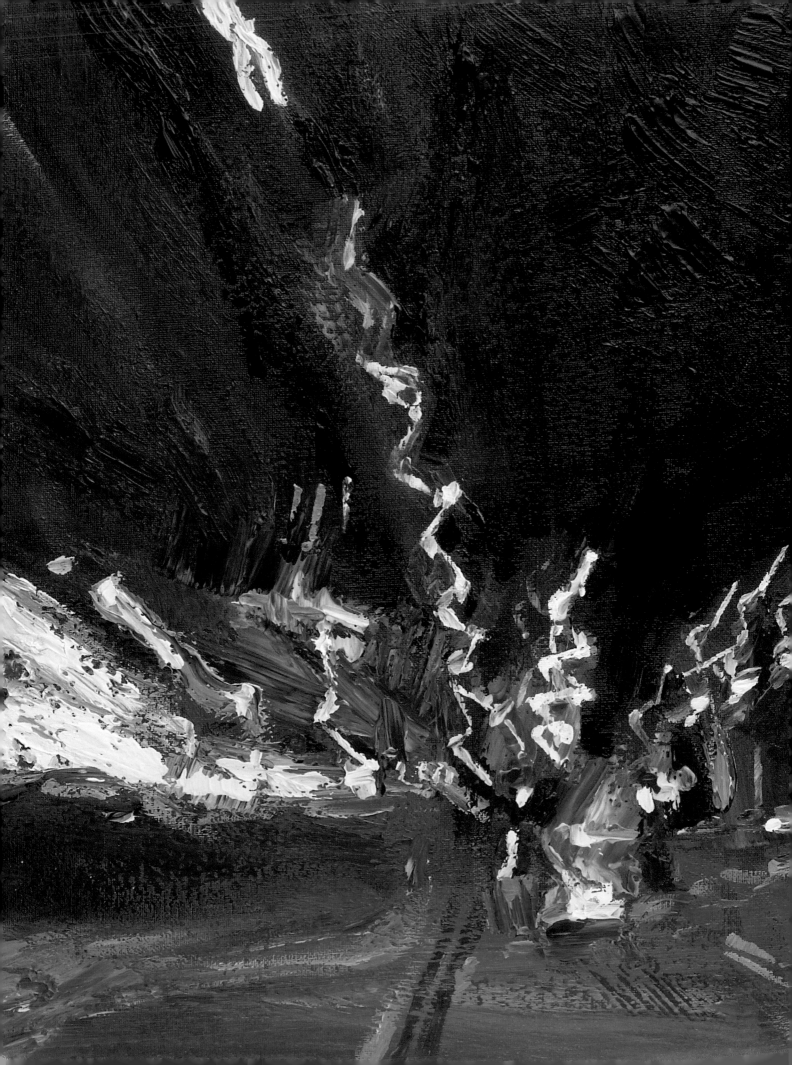

The finished painting

This painting is based on a photograph taken on a trip into London one evening. The multitude of street lights leading the way and illuminating the buildings have an abstract quality in their blurring and streaking. Contrasting darks and rich highlights give potency and the thick applications of paint means less fussing.

Index